IMAGES
of America

AURORA

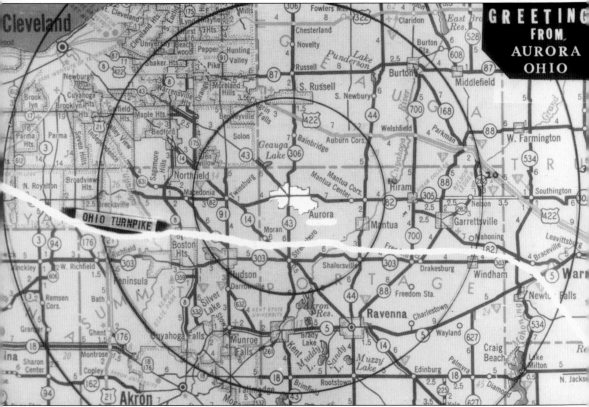

This postcard shows Aurora's location and its proximity to Cleveland, Geauga Lake, and the Ohio Turnpike. This advertisement helped entice vacationers to come to the area and enjoy a bit of fun and relaxation without traveling too far from home. (Courtesy Aurora Historical Society.)

On the cover: A group of ladies from Aurora, dressed in their bathing costumes, enjoy a sunny day at Centerville Mills. Centerville Mills was an industrial area in Aurora, while the lake was actually in Bainbridge. Pictured from left to right are Sister McDonald, Adelaide Baker, and Maude Russell. (Courtesy Aurora Historical Society.)

IMAGES
of America

AURORA

Marcelle R. Wilson and Richard Fetzer

ARCADIA
PUBLISHING

Published by Arcadia Publishing
Charleston SC, Chicago IL, Portsmouth NH, San Francisco CA

Printed in the United States of America

Library of Congress Catalog Card Number: 2007924630

For all general information contact Arcadia Publishing at:
Telephone 843-853-2070
Fax 843-853-0044
E-mail sales@arcadiapublishing.com
For customer service and orders:
Toll-Free 1-888-313-2665

Visit us on the Internet at www.arcadiapublishing.com

To Arthur and Ruth Moebius

CONTENTS

ACKNOWLEDGMENTS

Formally incorporated on August 1, 1968, the Aurora Historical Society really began much earlier in the hearts and minds of many residents who desired to preserve and showcase Aurora's interesting past. From the very beginning, the historical society would not have been a viable and thriving institution without the tireless, selfless, and unending contributions of its volunteers. They worked "behind the scenes," even before there was a museum, to collect, preserve, and restore historic objects, artifacts, documents, photographs, and memorabilia relating to Aurora and its past. It is impossible to thank all of those volunteers individually but without their contributions the historical society would not be. It is also important to recognize those founding members of the Aurora Historical Society and those dedicated souls who gave financial support to make the offices, museum, and staff possible. Volunteers who serve as docents also deserve special recognition for their contributions to keeping the museum open and our visitors informed. The historical society's mission is to enhance and maintain the community identity of Aurora by preserving and communicating its rich history, and it takes many hard-working people to achieve this goal and bring history to life! All of the wonderful images in this book come from the Aurora Historical Society archives.

INTRODUCTION

To many Americans, lands beyond the settled states of Pennsylvania, the Carolinas, New York, New Jersey, and the New England area were wild, barren, and fraught with dangers. Some people were not as inhibited by such images and had a desire to explore and settle the newly opened areas, which might offer opportunities not available in their present hometowns. Aurora began in 1799 as Ebenezer Sheldon became its first resident. Sheldon encouraged his friends and family to follow his example, and the population slowly but steadily grew. A majority of its earliest residents came from the Connecticut and New England regions of America and thus Aurora has maintained its Western Reserve sense of architecture in its many historic homes.

Aurora has always been known for its rural beauty, and perhaps that is what swayed many to settle here. Its history is largely agricultural, being mainly composed of farming families for decades. During the mid-1800s Aurora made a name for itself for its cheese manufacturing and shipped its product all over the country. This business continued as others in the community ran mills, stores, schools, and other concerns. The floods of 1913, which devastated so many Ohio towns and villages, also affected Aurora, wiping out its largest and most successful cheese manufacturers. Aurora and its people were able to recover and continued to pursue the business of agriculture but also modernized and diversified.

Today one can still see farms and rural areas around Aurora, as well as industry and a thriving building boom. The city maintains its bucolic beauty through local government initiatives, the Moebius Nature Center, its many parks, and the Audubon Society of Greater Cleveland's three sanctuaries.

I hope that the images in this book help capture the imagination of the reader, helping him or her see how life has evolved over the years. Many of the images evoke a sense of family, recreation, community, and pride. They help us visualize who lived in Aurora, the types of work, play, and environment that molded them and made the city what it is today. Aurora today is a diverse 21st-century town where one can fulfill the dream that drew so many early pioneers west to settle in a beautiful area, soon to be known as home.

One

FRIENDS AND FAMILY

When thinking of Aurora, whether about its history or how it exists today, one theme that is consistent and ever present is that of family and friends. Aurora began as a serene spot of wild beauty. Once discovered by restless Easterners, Aurora drew both the family and friends of its newest settlers, as well as those adventurous souls willing to journey out to the virtual edge of civility and begin their lives anew. The following chapter contains the images of many of the descendants of Aurora's earliest inhabitants and the scores of Americans whose pioneer spirit drove them to settle here.

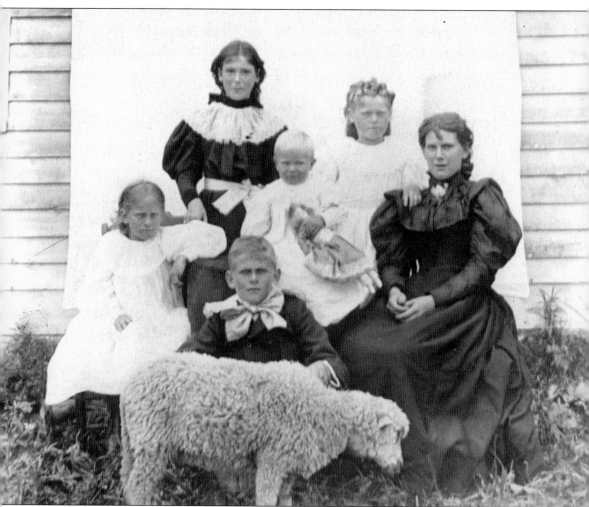

Even though Aurora was largely an agricultural village, its residents maintained their New England heritage through their mores and religious beliefs. The Lewis Cochran family lived on what is now Cochran Road and were farmers. They are pictured here from left to right: (first row) Alfred Cochran; (second row) Grace Cochran, Pearl Cochran, and Carrie Cochran; (third row) Mary and Ossie Cochran. The sheep was called Sippy Baa.

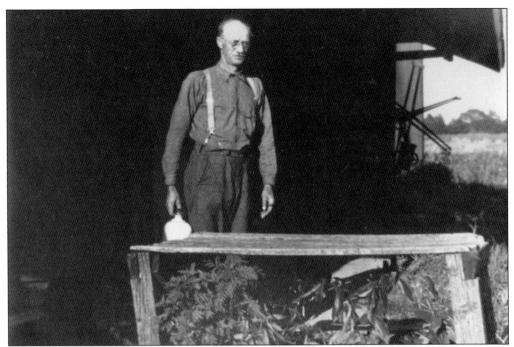

The Harmon family traced its Aurora roots back to the early 19th century. Here Calvin Harmon stands in the back of his barn at 1157 Page Road. Harmon, a fourth-generation Auroran, was a longtime member of the Aurora School Board. Harmon School is named in his honor.

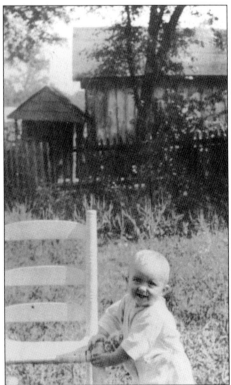

Pearl Cochran, daughter of Lewis and Phoebe Ann Stafford Cochran, smiles brightly as she steadies herself on a chair. She is in front of the Riley farm buildings, located on Cochran Road, around 1918.

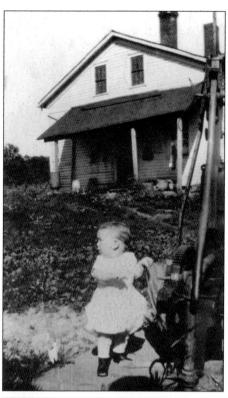

Ralph Kircher Jr.'s attention is distracted as he holds on to a windmill pump. The son of Robert R. and Mary Cochran Kircher, he stands behind the family farmhouse in Aurora.

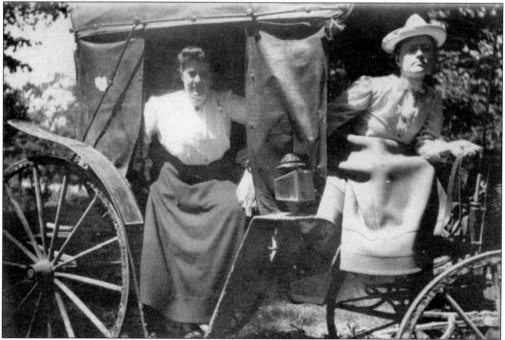

Sisters Josephine Hurd (left) and Bessie Hurd are seen here aboard the family surrey in Aurora in the early 1900s. Bessie later married Carl Ford and become the mother of longtime Aurora resident Seabury Ford.

12

Sisters Carrie Riley (left) and Kitty Riley (right), aged 5 and 13 respectively, pose in a photographer's studio in 1880. The girls' parents were Gurdon and Addie Riley. The Rileys lived on a farm near the end of Cochran Road.

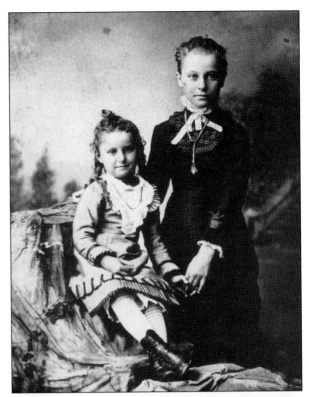

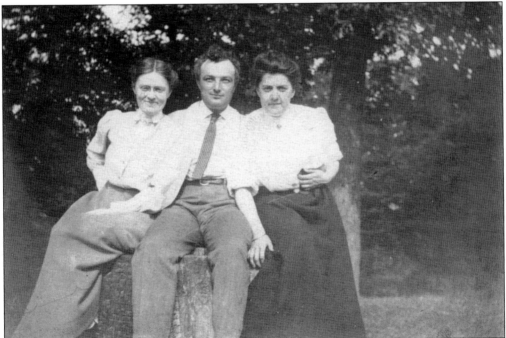

Friends Bessie Hurd (left), Louis Ford, and Josephine Hurd (right) enjoy the rural atmosphere of Aurora as their picture is taken seated on a tree stump. The women are the daughters of Frank and Caroline Hurd.

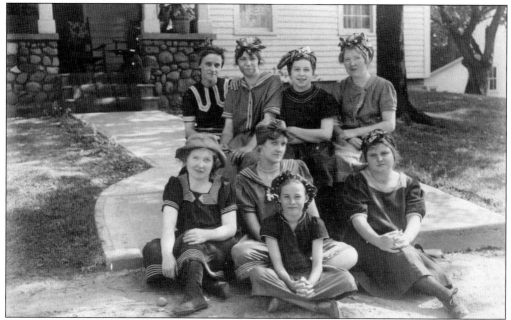

This group of Aurora girls is dressed for a day of fun in Centerville Mills. From left to right they are (first row) Sister McDonald; (second row) Myrtle Anderson, Mae McDonald, and Mae Russell; (third row) Maude Russell, Adelaide Baker, Louise Durffee, and Marion Anderson. Centerville Mills was a center of early Aurora manufacturing due to the waterfalls. The millpond served as a favorite swimming hole.

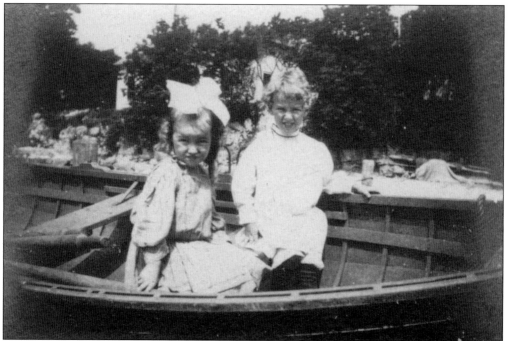

Seabury Ford and his sister await a boat ride on Geauga Lake. The lake, originally known as Giles Pond or Picnic Lake, located just at the Aurora border, proved very popular and drew visitors and summer residents from Cleveland, Akron, and other Ohio cities.

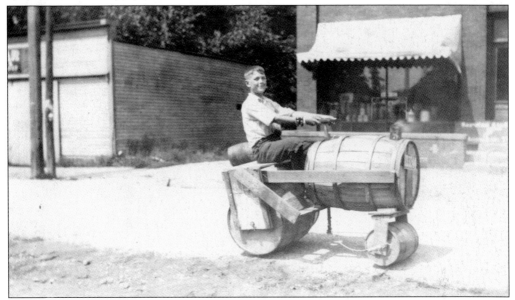

Victor S. Hurd rides his homemade tractor, outfitted with license plate, down Garfield Road past the A. B. Hurd general store at Aurora Station. (Garfield Road is also known as State Route 82).

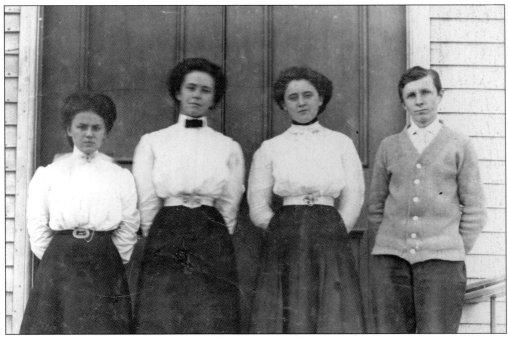

From left to right, Ada Poole, Myrtle Payne, Pauline Cannon, and Clarence Straight stand in front of the Aurora school in 1910. The girls sport the latest fashion of the Gibson girl, complete with hair placed neatly in buns. This building will be converted into Aurora's town hall in the 1950s.

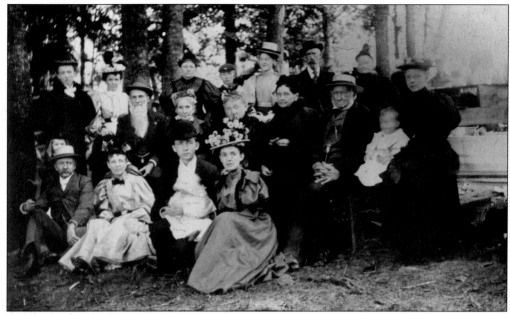

The Case family enjoys an outing and picnic at Geauga Lake in the late 1800s. From left to right they are (first row) Ed Case, Louise Case, Will Henry, Maude Henry, and unidentified; (second row) Mr. Estey, Mrs. Estey, Minnie Case, Melissa Case, Otis Case, Chester Berringer, and Mattie Berringer; (third row) Jesse Taylor, Emma Case, Rose Henry, Clarence Henry, Maude Case, Ace Eggleston, and Clara Eggleston.

Elinor Kent stands with her mother, Mary Bissell Kent. They are in front of their home at 451 Town Line Road. The house, built by Mary's father, Ebenezer Bissell, stands today.

The Aurora Historical Society has many photographs, similar to this one, of children posing for the camera. Here are the Straight siblings, from left to right, Kent, Clarence, and Helen Straight. These were the children of Leonora Kent and Ernest Straight. Their home was what is now 229 South Chillicothe Road.

These well-dressed children of the 1890s are the family of Lewis and Phoebe Ann Stafford Cochran. From left to right are Mary, Alfred, and Carrie Cochran. They lived on Cochran Road, where their father maintained a prosperous farm.

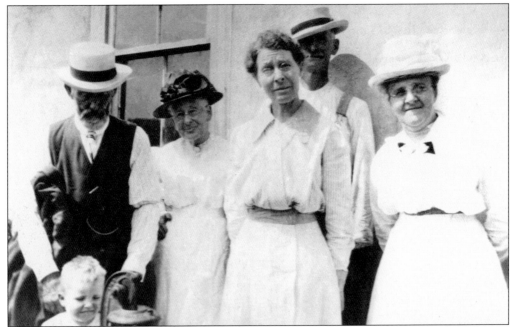

A gathering of family and friends was always one way to pass the time in Aurora. Pictured from left to right are Calvin Bissell, Addie Riley, Kitty Riley Wheeler, John Wheeler, and Libbie Bissell. In the front is Warren Little. Calvin was a prominent dairyman and cheese producer in Aurora during the late 1800s.

In 1920, Ernest and Lenore Kent Straight sit with their granddaughter Helen Louise Harmon. The Straights lived in town at 229 South Chillicothe Road in the Artemis Stocking house. Ernest worked as a bookkeeper at the Harmon Store. Lenore was the daughter of Zeno Kent III.

Olivia Hickox Sheldon was the wife of Albert Gersham Sheldon, a farmer in Aurora. Albert, a grandson of Aurora's founder, was affectionately known as "Doc."

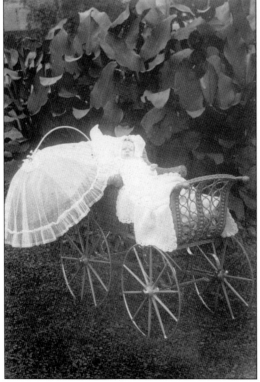

Here the infant John I. Eldridge lies in a very fashionable perambulator, equipped with a parasol for shade. John was the son of Willis and Jennie E. Burroughs Eldridge. They lived on the southwest corner of Maple Lane and Chillicothe Road. John was born in June 1896.

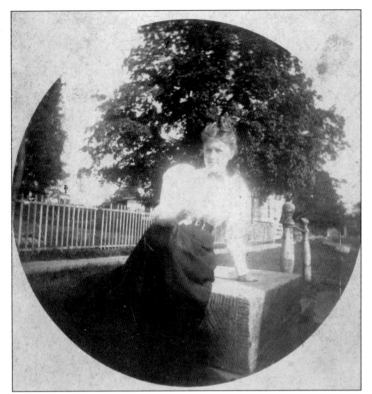

Elizabeth "Bessie" McKee Hurd leans against the carriage mounting stone at her home on South Chillicothe Road. In the background is the Gray Hotel. This is the only known existing photograph of the hotel on its original site, before it was moved to East Garfield Road, now Mario's Spa.

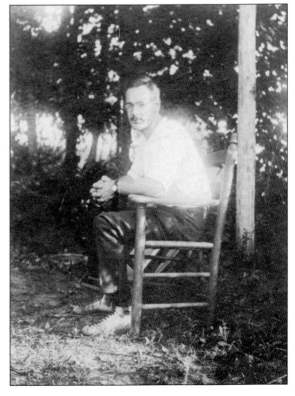

Here Dr. Leigh Baker of Cleveland, who married Isabelle Jackson, a descendent of the Aurora Jackson family, sits in his yard. The Bakers donated a portion of their land off Crackle Road to develop a youth camp. Leigh and his family summered at 1070 North Chillicothe Road, a home he and his wife inherited from the Jackson family.

Josephine Hurd Brewster was the daughter of cheese baron Frank and Caroline Hurd. She lived on the northwest corner of South Chillicothe Road and Maple Lane.

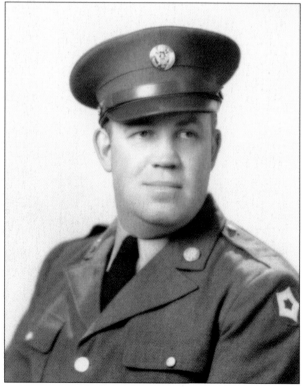

Bruce Biggar is here in his World War II uniform. He was a sergeant of headquarters company of the 1584th S.U. After the war he was a printer in Cleveland. He and his wife, Veron Gordon Biggar, lived in Aurora for over 20 years where she taught school. They were founding members of the Aurora Historical Society.

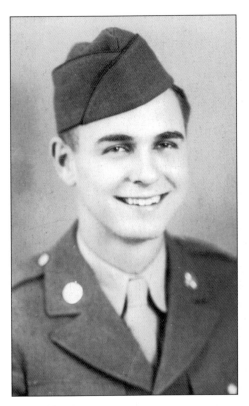

Pvt. Matthew Richard Mattmuller is seen here in 1944. He later became a pharmacist in Aurora. He served as Aurora's mayor from 1980 to 1984. He and his wife, Donna, are charter members of the Aurora Historical Society.

Claude Eggleston is pictured here in his World War I kit. Descendent of the pioneer Egglestons, he had a twin brother, Claire. They lived on Eggleston Road in Aurora. Claude died in the war. The Aurora American Legion Post No. 803 is named in his honor.

Here is Comdr. William Charles Helbig of the United States Coast Guard. The Coast Guard was instrumental in guarding local shores during the war. Helbig served in Cleveland during World War II. Comdr. Helbig's daughter, Jane Moulton, is a member of the Aurora Historical Society.

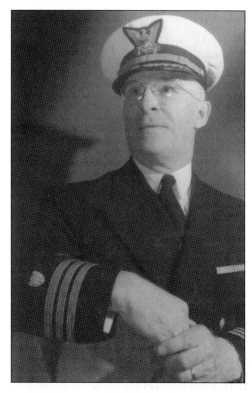

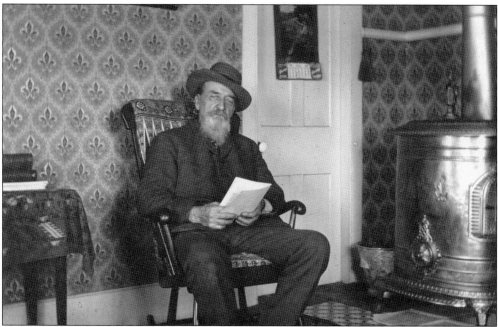

Charles Burroughs is seen sitting in his home. This glimpse shows how many of Aurora's residents lived. His house, 271 East Garfield Road, is just west of the railroad tracks at Aurora Station. He worked as a hotel keeper at the Aurora House on East Garfield Road. Burroughs, a Civil War soldier, is buried in Aurora Cemetery.

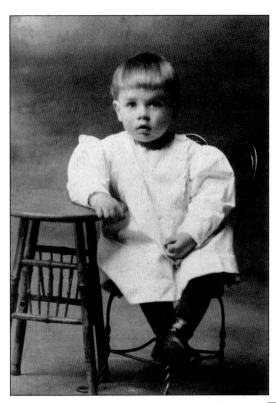

Ray Harmon was 18 months old when he sat for this picture in 1912. The youngest son of Calvin and Louise Harmon was born at 1157 Page Road. He was a lifelong farmer and active citizen in Aurora.

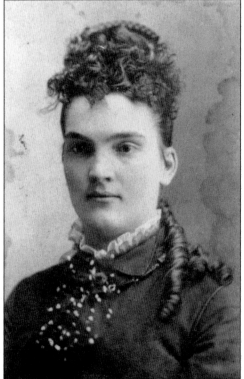

This is Amanda Heighton Straight, wife of Ernest Straight, who died in the 1880s. She is the mother of Edith Straight Harmon. Amanda died in 1889. Her granddaughter is Helen Louise Harmon Doubrava.

This is Harry Harmon at the age of seven, in 1870. Harmon married Edith Straight. They lived in the 1827 Federal-style home at 60 East Pioneer Trail. Harry was a grandson of Alanson Baldwin, the builder of the home. His parents were Charles R. and Orsa Harmon. Charles and Harry were, for many years, the proprietors of the Harmon Store at the center.

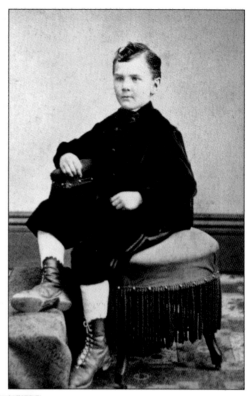

This delightful fellow is Seabury Ford in the early 1900s. His parents were Carl and Elizabeth Hurd Ford. Seabury, a founding member of the Aurora Historical Society, left many oral accounts of Aurora's history in the early and mid-20th century. He was an attorney in Cleveland and Ravenna, served as justice of the peace for Aurora Township, was a councilman from 1941 to 1945, and served two terms as Portage County prosecutor from 1945 to 1953. He was Aurora law director from 1965 to 1967. He was popularly known as the "Perry Mason of Portage County."

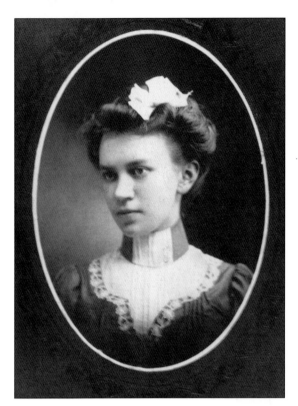

Effie Kent spent her childhood in Aurora. Her parents were Charles E. and Elsie Peck Kent later of Streetsboro, and her grandfather was Zeno Kent III.

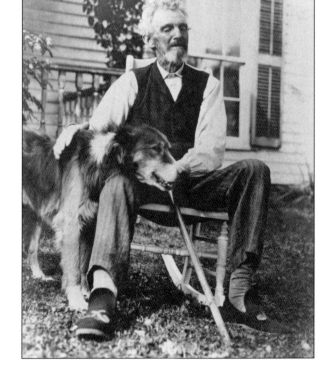

Gurdon Riley sits and pets his dog in this 1925 photograph. He was born and raised at the family home on Cochran Road. His daughters are Kitty Riley Wheeler and Mary Riley. Gurdon paid for a substitute to serve for him during the Civil War due to his age. He is buried in the Aurora Cemetery.

This is John I. Eldridge in the early 1900s. Eldridge grew up to be a major contributing member of the Aurora community. He served as a township trustee from 1946 to 1955, was the fifth mayor of Aurora from 1955 to 1959, and was responsible for uniting the village and township in 1959. He was also a founding member of the Aurora Historical Society.

The fashionable Elizabeth (Bessie) Hurd, wife of Carl B. Ford, is seen as she appeared in the late 1880s. She was cheese baron Frank Hurd and Caroline White Hurd's daughter and the mother of Seabury Ford. She was a major contributing member of Aurora society for her entire life.

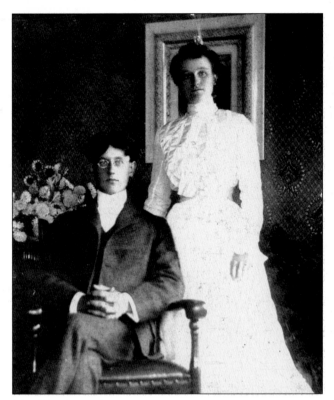

Loy and Ethel Bissell sent this photograph postcard of themselves to Minnie Russell as a Christmas gift in the late 1890s. Loy was born in Aurora in 1876, the son of Sylvester Bissell. He lived in the Parker Road area and worked the family farm.

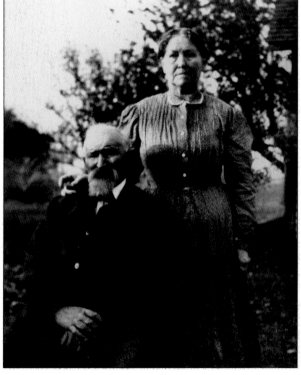

Lot and Mary Ann Laughlin pose for the camera in 1900. The Laughlins lived in Aurora, on East Garfield Road, near Aurora Station. Lot worked for the railroad, most likely drawn to the area from Ireland for that work.

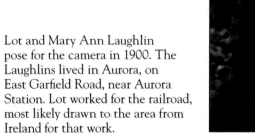

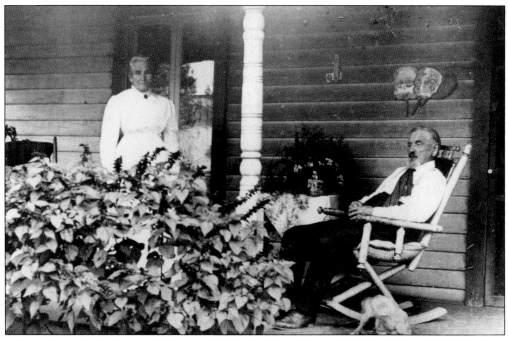

Daniel D. and Helen Tucker are photographed at their home at 486 East Garfield Road, known as the John Preston House. This home originally served as a sawmill and woolen factory and was built in 1850. Daniel, a Civil War veteran, is buried in the Aurora Cemetery.

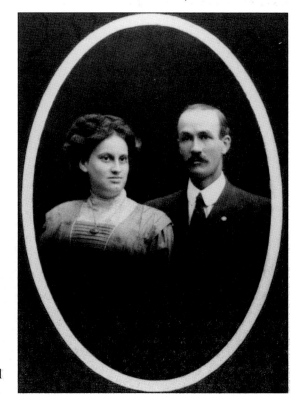

This is the wedding photograph of Calvin and Louise Kingsley Harmon, from February 1910. Calvin Israel Harmon was born on the Harmon homestead, on Page Road, in 1875, the son of Sherman and Elizabeth Hope Harmon. He was a member and president of the school board and a local farmer. He is the father of Ray Harmon.

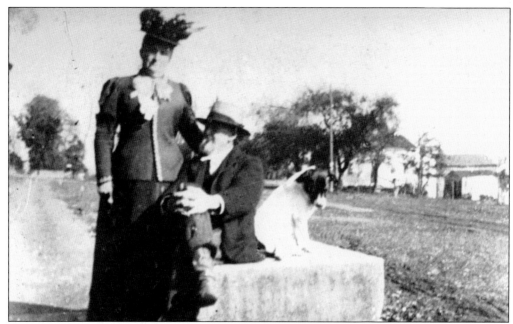

Pictured here are cheese king Frank Hurd and his daughter Josephine in the 1860s. They lived at 28 South Chillicothe Road. Hurd, a cheese merchant, owned and operated eight cheese factories in northern Ohio. His Aurora factory, the Silver Creek Cheese Factory, stood on the east side of the Chagrin River, on East Garfield Road. This picture shows the carriage mounting stone at his home. In the background, the local harness maker Columbus Jewett's house is visible (right). Jewett's home is now located at 73 Maple Lane. Hurd had three daughters, Josephine, Elizabeth (Bessie), and Carrie Louise—popularly known as "the belles" of Aurora.

Here are Al Yost, his wife Helen Straight Yost, and their niece Helen Louise Harmon in 1919. They are in front of the Charles Harmon barns on East Pioneer Trail near the town center.

This 1880s image shows Lewis P. and Phoebe Anne Stafford Cochran. The Cochran family lived on Cochran Road, in the Julius Riley home, which burned down in the 1980s.

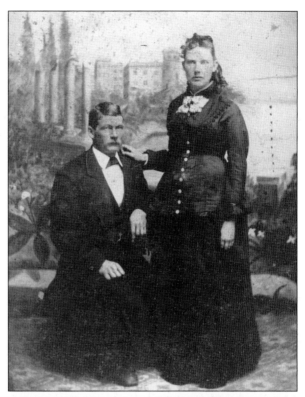

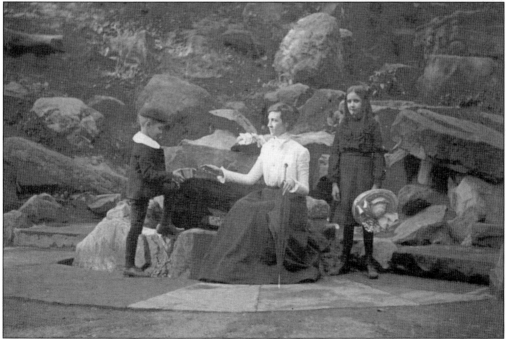

Here is a rural image of Isabelle Jackson Baker and children in the late 1880s at their farm near Centerville Mills. Her husband was Dr. Leigh Baker of Cleveland. Isabelle is a descendant of John E. Jackson, early settler, and Aurora abolitionist preacher.

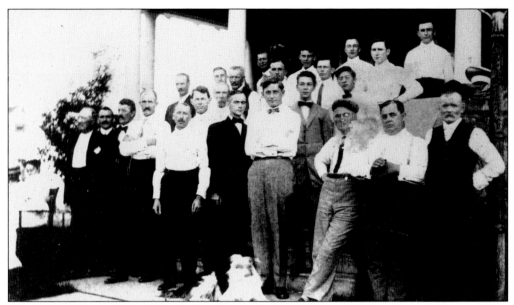

The Aurora Brass and Reed Band held a reunion in 1915 at Harry Harmon's house. They are, from left to right, (first row) unidentified, unidentified, unidentified, Gordon Treat, W. H. McDonald, Gilbert Merrell, Edward Robinson, Harry Harmon, Theodore Thompson, and unidentified; (second row) Oscar Gilbert, unidentified, Vernon Rehm, and Carl Fitzmeyer; (third row) Calvin Harmon, Carl Kent, Edward Elliman, unidentified, unidentified, unidentified, Louis Eggleston, Claude Eggleston, unidentified, and Lee Gould.

Charles and Carrie Harmon stand in their yard in 1921. The couple lived at 84 South Chillicothe Road, in the home built by the Reverend John Seward.

Here are Neil Ford (left) and Frank Hurd, friends and business associates. Ford came from Chardon, and Hurd was born in Aurora. They were both engaged in the cheese industry.

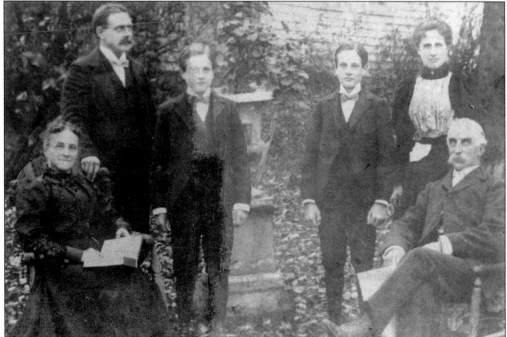

The Eldridge family is seen here at their home on the southwest corner of Mennonite and Chillicothe Roads, about 1900. From left to right are Mary Cook Eldridge, Willis Eldridge, identical twins Edward and Edwin Eldridge, Florence Eldridge, and Horace Eldridge.

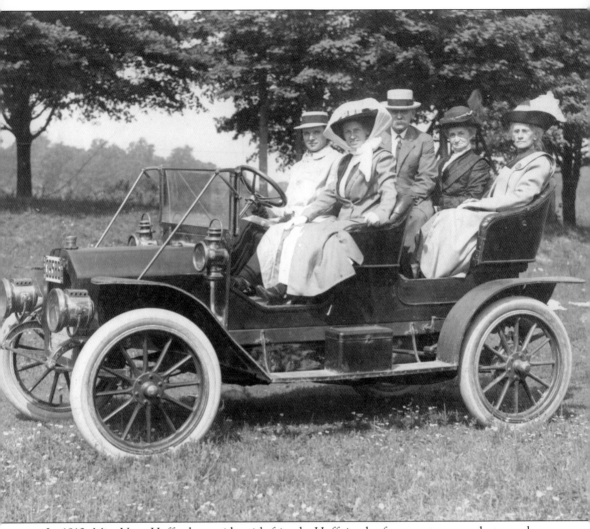

In 1912, Miss Vern Huff takes a ride with friends. Huff, in the front seat, was a photographer. She left many images of the early residents of Aurora and Bainbridge. She was from Cleveland, summered in Aurora, and boarded at a house on Crackle Road.

Two

RELIGION AND EDUCATION

Aurora residents came from the New England states and many brought their religious beliefs with them, while others moved out of New England to get away from its restrictive religious imposition of rules and regulations. Initially Aurora was served by traveling ministers and missionaries but eventually grew to boast numerous religious groups and churches. Among the many religious organizations and groups found in Aurora were and are Campbellites, the Congregational Church, the Church in Aurora, the Disciples of Christ Church, the Baptist Church, the Roman Catholic Church, Our Lady of Perpetual Help, Lakeview Chapel, Hope Lutheran Church, Aurora United Methodist Church, First Baptist, Aurora Mennonite Church, New Life Assembly of God, and the Mantua Country Baptist Church. In addition to religious beliefs, Aurora's citizens also strongly believed in the edifying effects of education. Aurora's children attended neighborhood schools or the Aurora Academy until 1886 when the school system was centralized into a single building. To supplement their income, many ministers and other young men tutored children too.

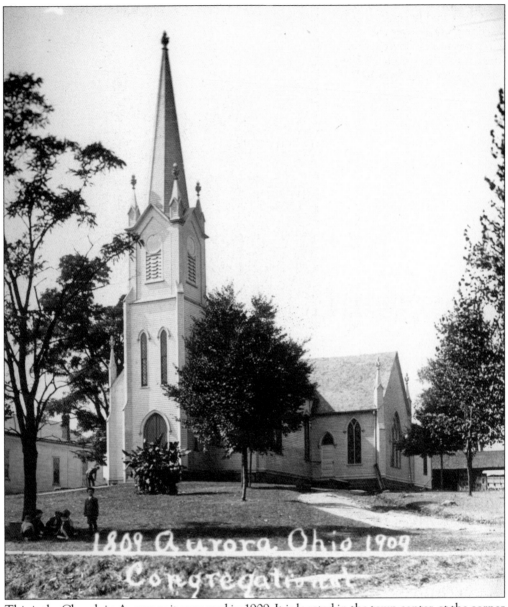

This is the Church in Aurora as it appeared in 1909. It is located in the town center, at the corner of Pioneer Trail and Chillicothe Road. This is one of Aurora's most photographed buildings.

The Reverend James H. McKee presided over the Congregational Church, now the Church in Aurora. McKee served as minister from 1897 to 1908.

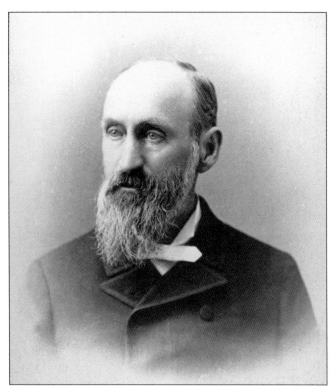

This is Rosalie McKee, Rev. James H. McKee's wife. The McKees had two children, a daughter, Alice, and a son, Henry.

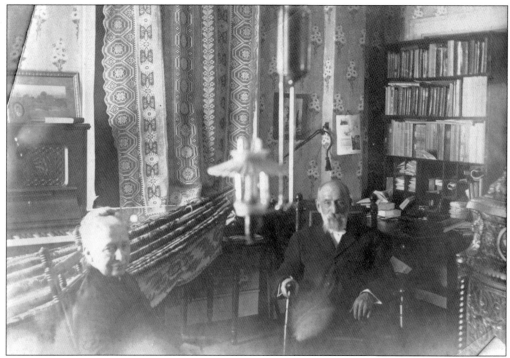

Rev. James and Rosalie McKee lived in the parsonage provided by the Congregational Church. Here is an intimate view of the couple at home at 270 South Chillicothe Road.

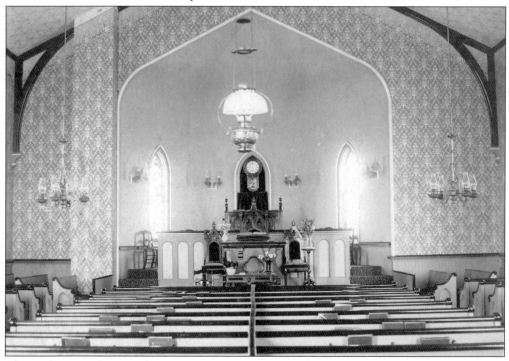

This is the Congregational Church sanctuary as it appeared in the 1920s. In 1933, it became known as the Church in Aurora.

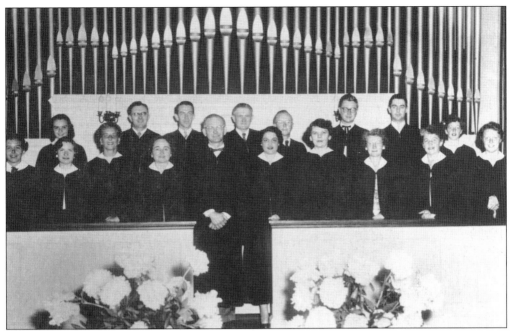

Choir members of the Church in Aurora in 1951 are, from left to right, (first row) Phyllis Swartz, Shirley Hale, Lee Tabor, Katherine Livengood, Herbert Livengood, Shirley Baylor, Elizabeth Swartz, Charlotte Morrison, Martha Truthan, and Barbara Barrick; (second row) Susan Bradley, William Thomas, William Walton, Edward Truthan, Guy Williams, George Morrison, Charles Petot, and Dorothy Spencer.

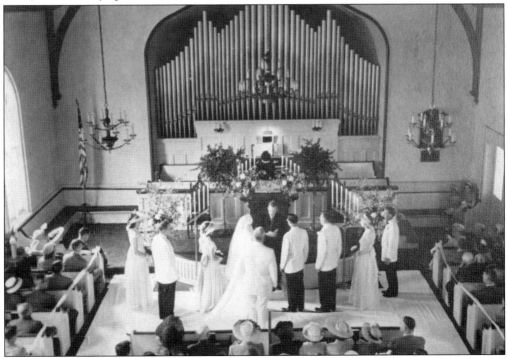

This 1960s-era wedding took place in the Church in Aurora.

The Aurora Plainview Mennonite Church is located on the corner of Mennonite and Chillicothe Roads. There is a cemetery in the rear of the building with burials from the days of Aurora's pioneers to the present.

The Aurora Mennonite Church celebrated its 100th anniversary on November 5, 2005. Originally known as the Aurora Plainview Mennonite Church, the founding Amish Mennonite settlers came from other states as well as Holmes County. They wished to farm and establish a church in which they could celebrate the Sabbath. The church established its Sunday school in 1906 and constructed a new building in 1912.

This is the Aurora United Methodist Church as it appeared in 1968. It is now located at 241 Aurora Road and was built in 1962 with an addition completed in 1997, making the sanctuary larger by 50 percent. The building contains the pastor's study, four classrooms, a fellowship hall, and a kitchen. Allen T. Snyder served as the church's first pastor in 1957. Rosa B. Clements is the current pastor, hired in 2005.

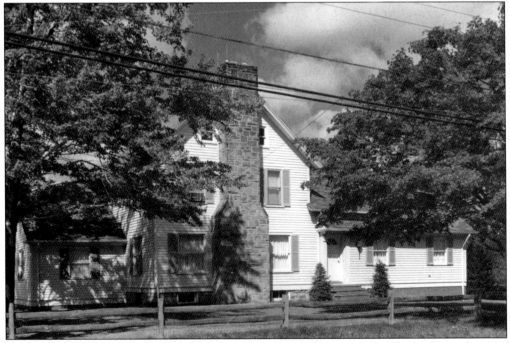

This is a photograph of the parish house of Our Lady of Perpetual Help Church located on the corner of South Chillicothe and Aurora–Hudson Roads in 1968. It was originally the home of George Eggleston.

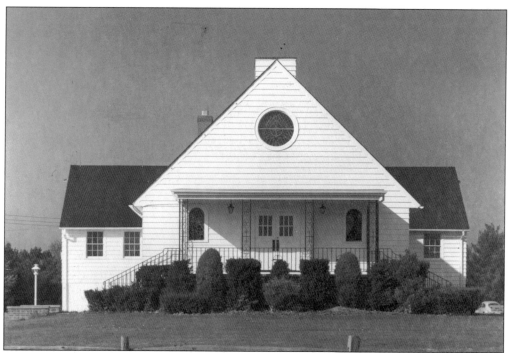

This is a 1968 view of Our Lady of Perpetual Help Church from South Chillicothe Road. This building was moved from Solon to this location.

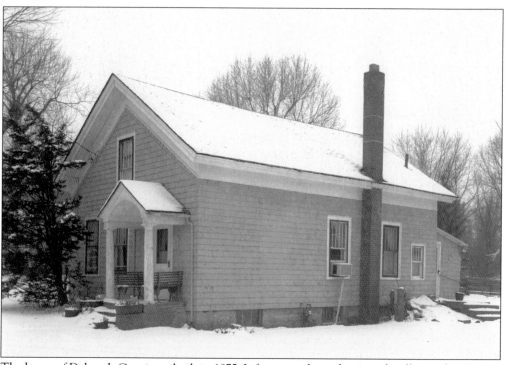

The home of Deborah Conti was built in 1875. It first served as a district schoolhouse for Aurora. It is located at 234 South Chillicothe Road.

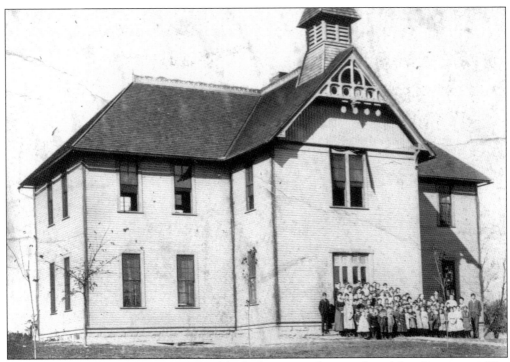

In 1900, this is how the Aurora school looked as its students gathered for this picture. The school became the town hall in the 1950s.

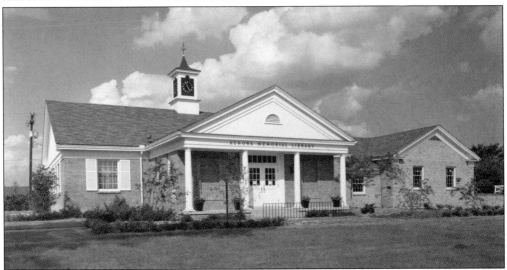

The idea for the Aurora Memorial Library, 115 East Pioneer Trail, actually began in 1947 as a way to honor nine soldiers killed in World War II. A group of parents purchased several lots of land and mounted a plaque inscribed with the names of those lost on a boulder and located it near a cannon to memorialize the town's losses. The library was built with a generous donation from the Chapman family to honor the memory of George Byron Chapman and opened to the public in 1966. The building grew as more funds were donated by Kitty Wheeler. In 1991, the public financed, via a tax levy, another addition, doubling the size of the structure. Now the building houses the library, the Aurora Historical Society, and the Aurora Community Theatre.

This is a view of the theater building from across Chillicothe Road.

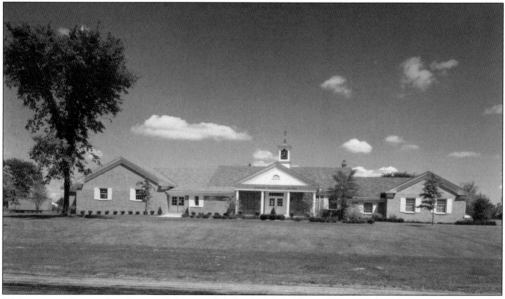

This image shows the Aurora Memorial Library with the addition of the theater wing. The Aurora Community Theatre (ACT) was formed in 1959 by Elizabeth and Jack Colebrook and their friends. The theater originally held many of its rehearsals and shows in the Church of Aurora and the Aurora High School before it had its own theater and rehearsal space. This space was a 1971 addition to the library and named the Performing Arts Center. It expanded over the years to include a stage, wardrobe room, and rehearsal space.

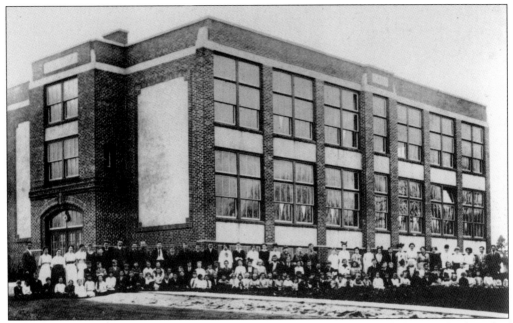

The Aurora School was built in 1912 on East Garfield Road. It currently houses the board of education and several classes. It is named Craddock Elementary.

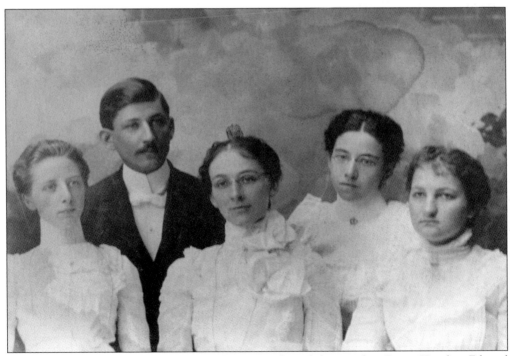

The Aurora senior high school class of 1900 is, from left to right, Grace Towsley, Edward Robinson (principal), Elizabeth Harmon, Ida Niman, and Edith Straight.

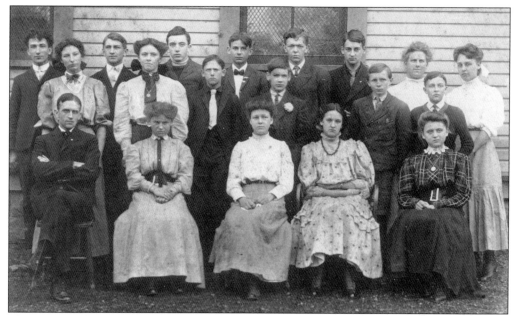

This Aurora school class was made up of, from left to right, students (first row) Alexander Walter, Ada Poole, Viola Plum, A. Baker, and Pauline Cannon; (second row) Florence Elliman, Myrtle Payne, Walter James, unidentified, Clarence Straight, and Claire Eggleston; (third row) Horace Egbert, unidentified, Ralph McDonald, Karl Kent, Earl Culman, Lee Isham, Grace Cochran, and Ethel Wolfcomer.

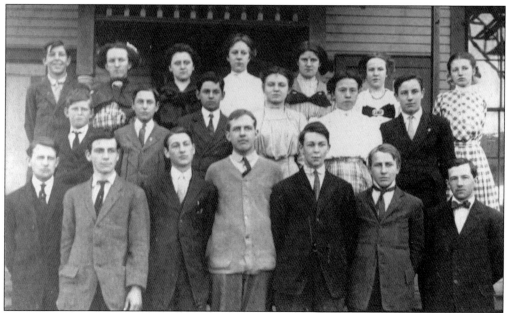

The 1911 Aurora High School class group is, from left to right, (first row) ? Hawk, Herbert Lake, Alexander Hawk, John I. Eldridge, Vernon Rheem, Frank Fleshman, and Lloyd Blauch; (second row) Elmer Cochran, Max Reed, Elmer Sly, Grace Beaters, Elinor Fisher, and William Knopf; (third row) Carl Adrion, Byrl Hatch, Pauline Cannon, Ida Krause, Pearl Cochran, Hazel Pleasance, and Helen Straight.

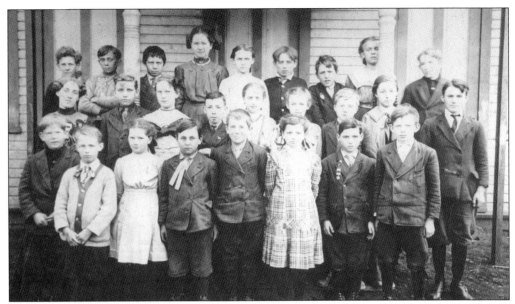

The 1912 fifth-grade class at Aurora school includes, from left to right, (first row) Clarence Harris, Seabury Ford, Stella Blauch, Roy Raber, Clemens Blauch, Gladys Stoltzfus, Lloyd Egbert, and Clarence Jackson; (second row) Mabel Russell, Frank Raber, ? Cochran, Harold Miller, unidentified, Erma Hawken, Howard Niman, Norman Irwin, and Merle Poole; (third row) Harold Mills, Bill Youppi, ? Mowl, Anna ?, unidentified, unidentified, unidentified, Lena Youppi, and Floyd Harris.

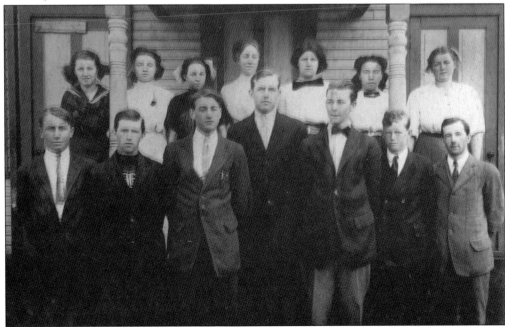

The 1912 Aurora High School class group from left to right shows (first row) Frederick Falkenburg, Norbert Blauch, Alexander Hurd, John I. Eldridge, Vernon Rheem, Elmer Cochran, and Lloyd Blauch (school superintendent); (second row) Helen Straight, Grace Baiters, Myrtle Anderson, Ida Krause, Pearl Cochran, Elinor Fisher, and Hazel Isham.

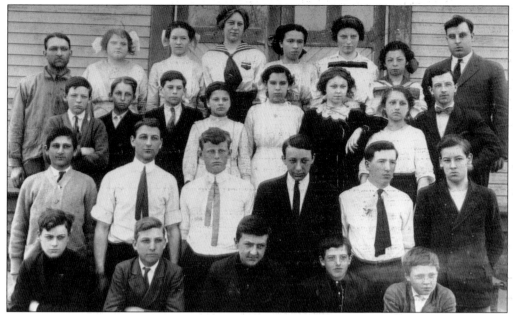

The 1913 Aurora High School class group is seen here. From left to right are (first row) unidentified, Franklin Raber, unidentified, unidentified, and Howard Niman; (second row) unidentified, Alexander Hurd, Elmer Cochran, Walter Fields, Omar Blaugh, and Paul Whitehead; (third row) Howard Jackson, Roy Raber, unidentified, Gladys Stoltzfus, Gladys Hostettler, Lucille Miller, Gladys Payne, and Lloyd Blauch; (fourth row) Leslie Hurd, Louise Durffee, Alta Mowl, Ida Krause, Elinor Fisher, Ruth Elliman, Tessie Jackson, and unidentified.

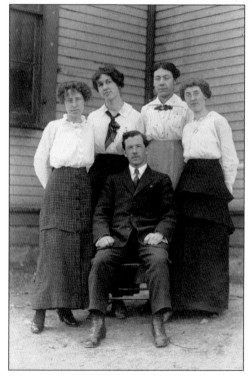

Here Aurora's schoolteachers pause for their picture to be taken in 1914. From left to right are Pauline Hill, Helen Crane, Ruth Messenger, Mabel Russell, and Lloyd Blauch (seated).

Three

RURAL BEAUTY

When the first settlers ventured out from New England to the frontier, they found in Aurora a beautiful wilderness that could, with a great deal of work, suit their needs. Aurora in its natural state would provide adequately, even abundantly, if the pioneers were willing to exert themselves in taming the rough country to create a home for themselves and their families. They found thick forests, fertile land, and many sources of water. In addition, they dealt with mosquitoes, swamps, wild animals, accidents, illness, and death. In forming their town, the pioneers bequeathed a new, exciting place for future generations to live, work, and play.

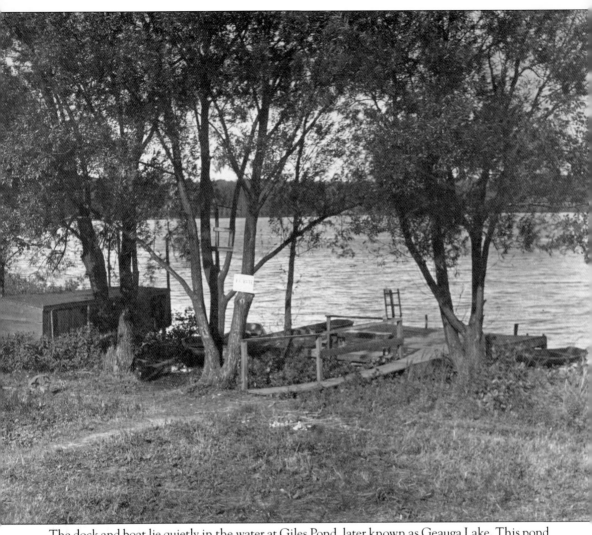

The dock and boat lie quietly in the water at Giles Pond, later known as Geauga Lake. This pond provided endless hours of recreation and a source of food for Aurora's natives as well as visitors.

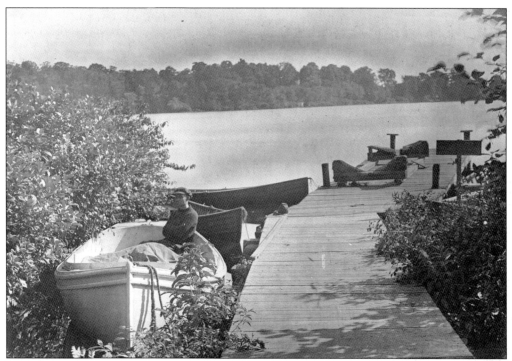

Lake photographs are among the most popular images of Aurora. Here a man sits in his rowboat at his dock at Geauga Lake.

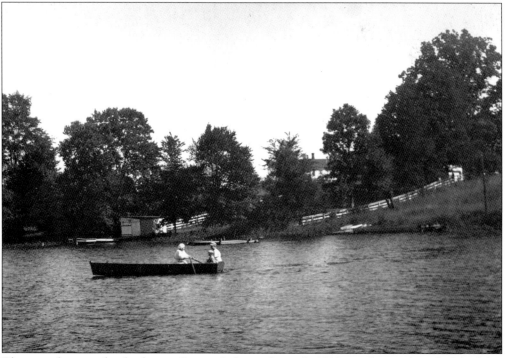

This is a photograph of a day on Geauga Lake in the early 1900s, at the south end of the lake. Although the boathouse no longer exists, the home in the distance remains standing.

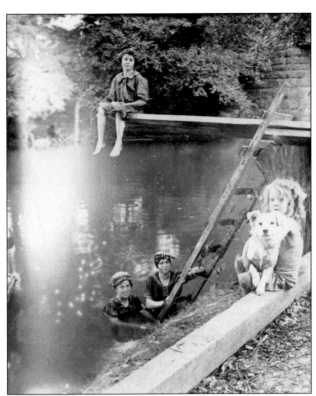

Some friends enjoy a day at the YMCA camp on Crackle Road. This photograph dates from the 1920s.

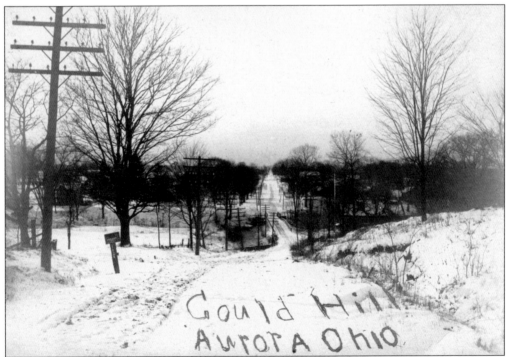

Here is a view of Gould Hill in the early 1900s. This image is looking west along East Garfield Road.

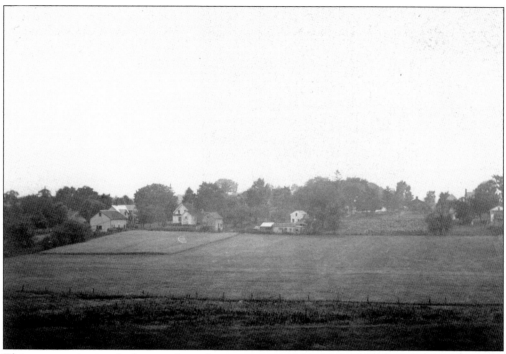

This panoramic view looks west from the present site of the Aurora Middle School. It shows the corner of East Garfield Road and the properties along the east side of Chillicothe Road.

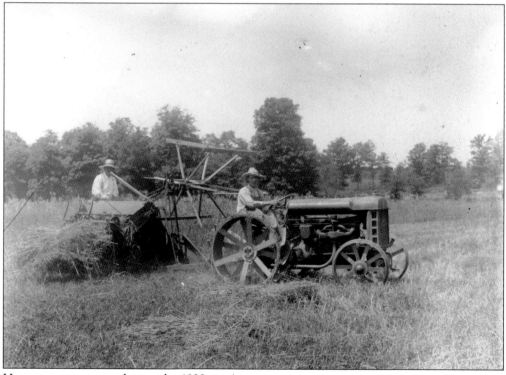

Here are men mowing hay in the 1920s in Aurora.

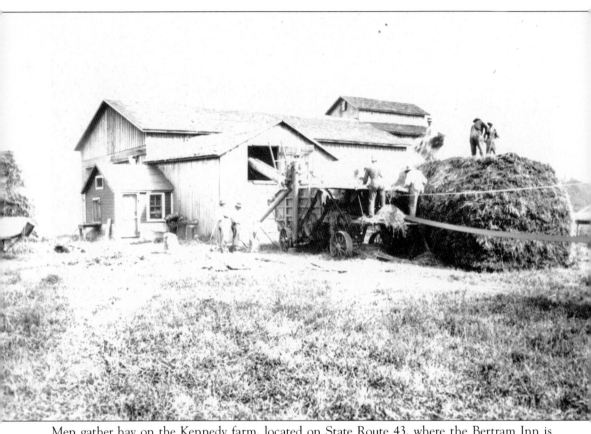

Men gather hay on the Kennedy farm, located on State Route 43, where the Bertram Inn is presently located.

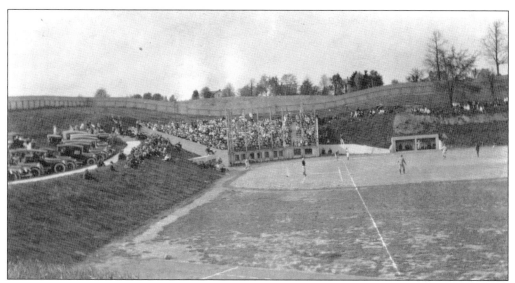

Baseball is one of summer's most popular pastimes, especially in Aurora. Cleveland baseball teams came to Aurora in the early 1920s to play on Sundays. Blue laws enforced in Cleveland, but not in Aurora, forced Cleveland teams to travel here for their games. The baseball diamond and stands were in Geauga Lake Park, and here a game is in progress.

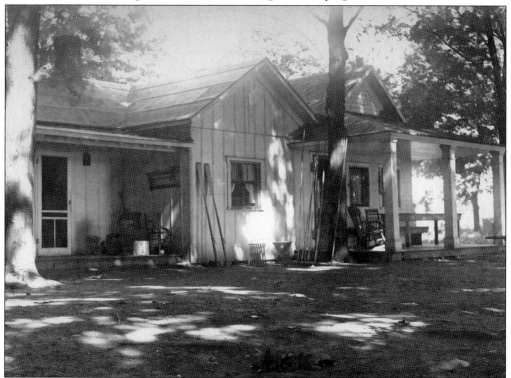

Many Clevelanders summered in the Aurora area. They built cottages, which eventually became full-time homes. This cottage shows the various recreational activities one might engage in during vacation, since boating, fishing, hunting, and camping were popular and Geauga Lake Park was nearby.

Rural Aurora residents relied on wood for heating their homes and cooking prior to electrification. Here the wood pile for the Willis Eldridge family's stove behind their home at 50 South Chillicothe Road can be seen. Today Chillicothe Road is a busy road, with trucks and cars traveling its length at all hours of the day and night.

This is John I. Eldridge's makeshift chicken coop. The James Jewett residence and gardens, located at 29 Maple Lane, appear in the background.

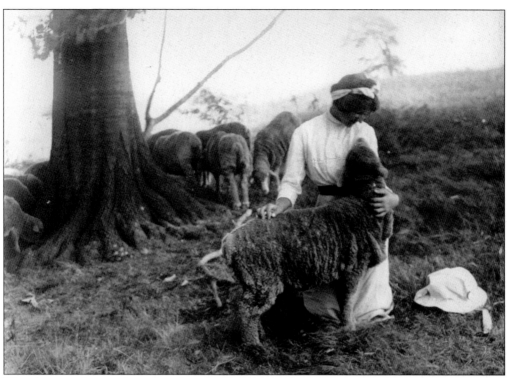

The photographer catches a bucolic image of a woman and sheep in the early 1900s.

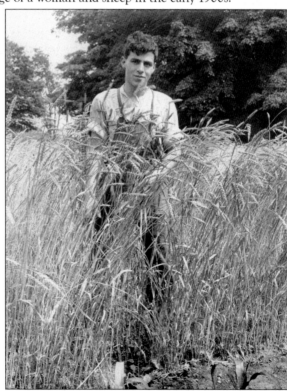

An Aurora farmhand is pictured here in a wheat field in the early 1900s.

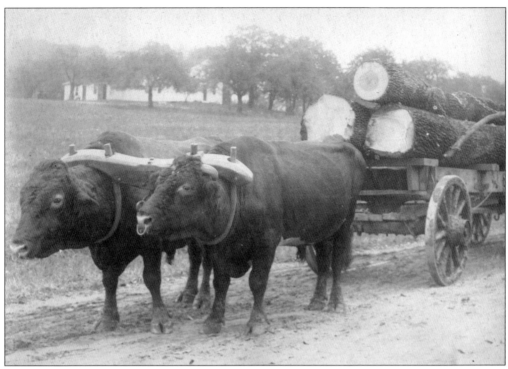

A yoke of oxen haul logs to the lumber mill.

This is a view of the Gurdon L. Riley farm, located on Cochran Road.

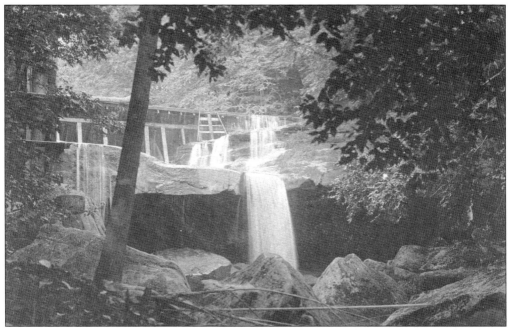

Here is an image of the Centerville Mills dam, which was located on the Aurora side of Crackle Road.

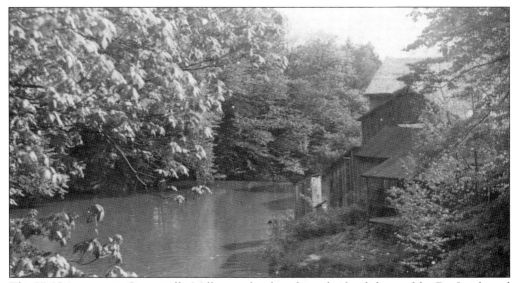

The YMCA camp at Centerville Mills was developed on the land donated by Dr. Leigh and Isabelle Jackson Baker. The view is looking south, down the stream toward the dam.

This early-20th-century view looks south on the east side of South Chillicothe Road past the homes that Artemis Stocking and David Shephard built.

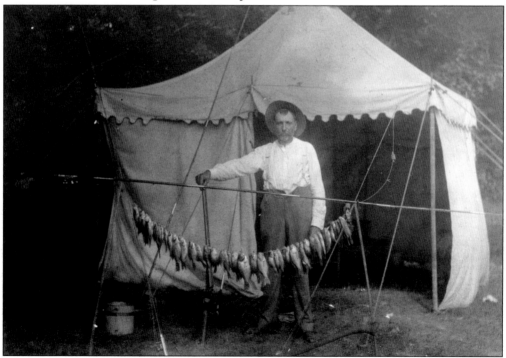

A fine catch on Giles Pond shows that the fish were plentiful. This recreation area was loved by many visitors who camped, fished, and hunted there in the mid- to late 1800s.

The falls at Centerville Mills in the early 1900s is shown in this photograph. Dr. Leigh K. Baker, his wife Isabelle Jackson Baker, and their children pose in the glen below the dam. Many families enjoyed hiking, fishing, or picnicking here throughout the summer.

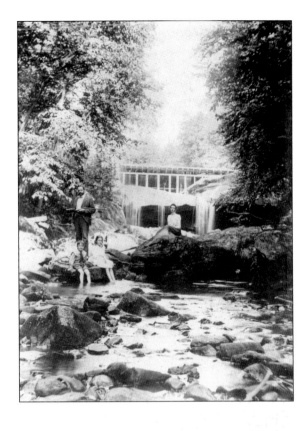

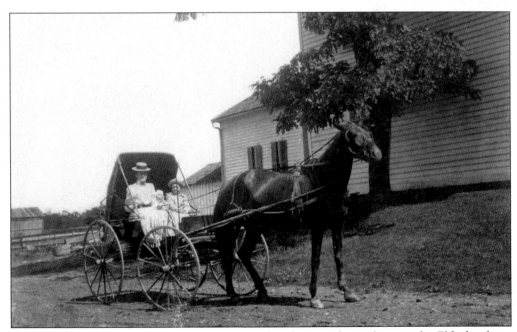

The Mowl family is seen on its way to town. The photograph is taken on the Eldridge farm, located on Aurora–Hudson Road.

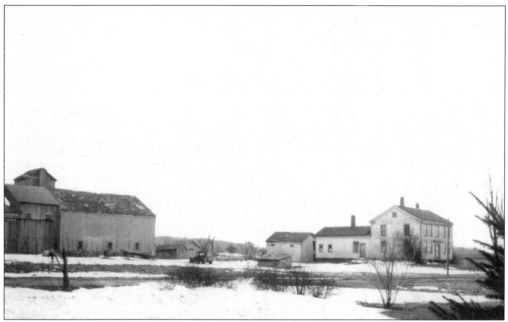

This is the Zeno Kent II house and farm as it was in the 1920s. This home is located at 1241 Aurora–Hudson Road. Construction began on the house in 1814. It is an example of a typical five-bay, central-chimney farmhouse.

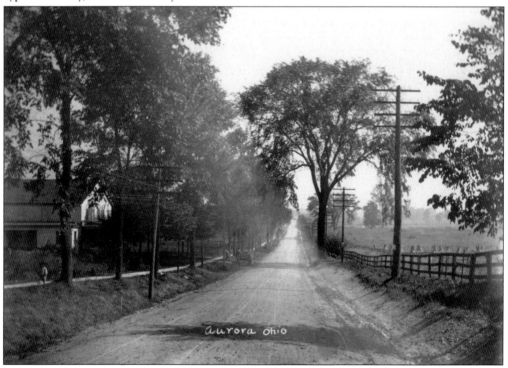

This is an early view of Main Street, Aurora, in 1900. The photograph was taken looking east on Garfield Road from State Route 306. The Gray Hotel is visible on the left. It was moved to this location by its owners, the Hurd family, from its original site on South Chillicothe Road.

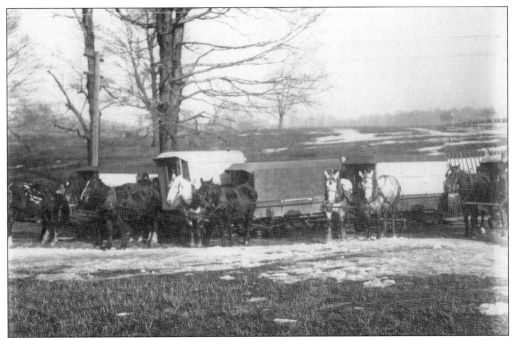

Aurora's earliest school buses are seen serving the children of the community. The central school district employed horses and wagons to bring children from all over the village to the Central School (now the city hall) in the early 1900s.

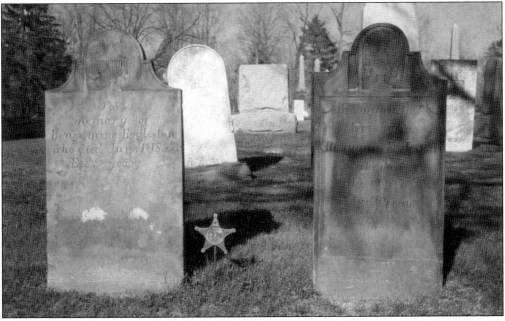

The Aurora Center Cemetery, located on South Chillicothe Road, was established in the early 1800s. Buried here are Aurora's early settlers, as well as veterans from the American Revolution, War of 1812, Civil War, World War I, World War II, Korean War, and Vietnam War. Here are the headstones of early settlers Benjamin Eggleston and his wife, Mary. The stones bear hand-carved inscriptions as well as New England–styled decoration.

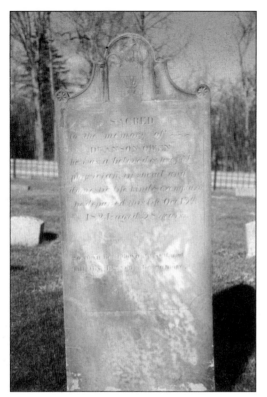

"So man lieth down and riseth not till the Heavens are no more." This is a tribute to Dr. Anson Owen, who began his Aurora practice in 1818. He died six years later, leaving a wife, son, daughter, and many distraught patients.

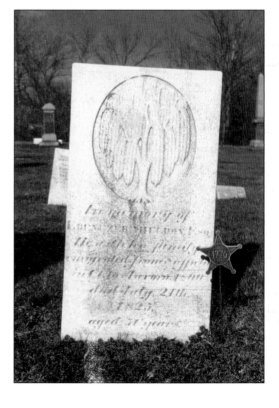

Aurora's first settler, Ebenezer Sheldon, came from Suffield, Connecticut, to Aurora in 1799. He served as a captain in the American Revolution and contributed to Aurora as a trustee, justice of the peace, land agent, and postmaster. His wife was Lovee Davis Sheldon.

Rhoda Cochran's tombstone has suffered the ravages of time and weather. She was the daughter of John and Rhoda Ferguson Cochran. Her family left Massachusetts in 1806 for Aurora. Her father died in Buffalo, New York, and the family continued its journey. Suffering from rheumatism, the walk to Aurora was very difficult for Rhoda, who died shortly after arriving. She was buried on December 25, 1806, in the cemetery located on State Route 43.

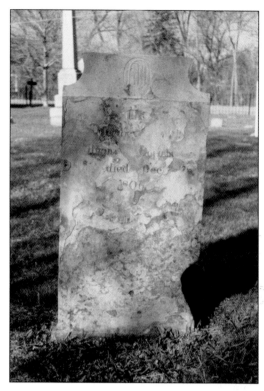

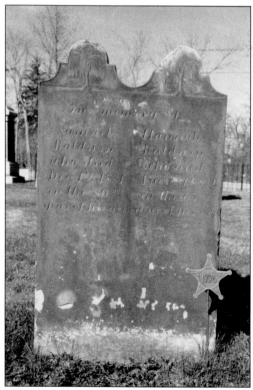

Samuel and Hannah Northrup Baldwin married on December 9, 1772. They had 11 children, 7 sons and 4 daughters, all born in Danbury, Connecticut, prior to their move to Aurora in 1807. Samuel was an American Revolutionary War veteran.

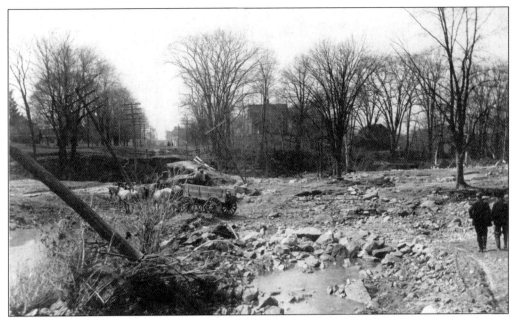

The year 1913 was tough weather-wise for many towns in Ohio. Aurora Station suffered great damage with the collapse of the railroad embankment constructed across the Chagrin Valley. The ensuing flood washed away many of Aurora's small industries and marked the demise of Aurora's place as America's great cheese producer and shipper. This picture is of the Chagrin Valley after the flood on East Garfield Road looking west.

Sunny Lake, created during the glacial period 12,000 years ago, was originally known as Harmon Pond. Located near the convergences of Page and Mennonite Roads and Pioneer Trail, much of the surrounding land was owned by the Harmon family. In the winter, they supplied ice, which they cut from the frozen lake, to surrounding communities.

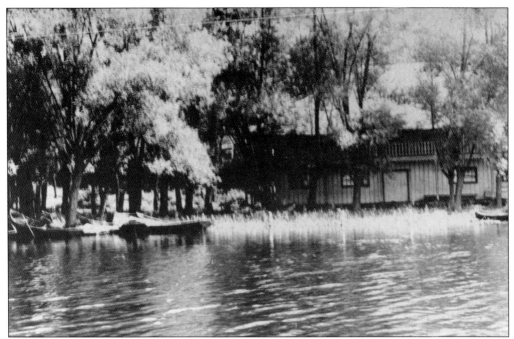

The amenities at Geauga Lake in the late 19th century provided a place to picnic, dance, camp, hike, fish, and boat. Here is a view of the pavilion and picnic grounds, located near the Geauga Lake train station.

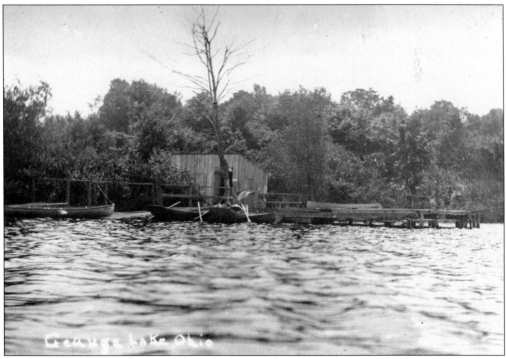

The dock and boathouse on Geauga Lake allowed residents and visitors to enjoy the water. Men and boys could fish from the dock or from small boats.

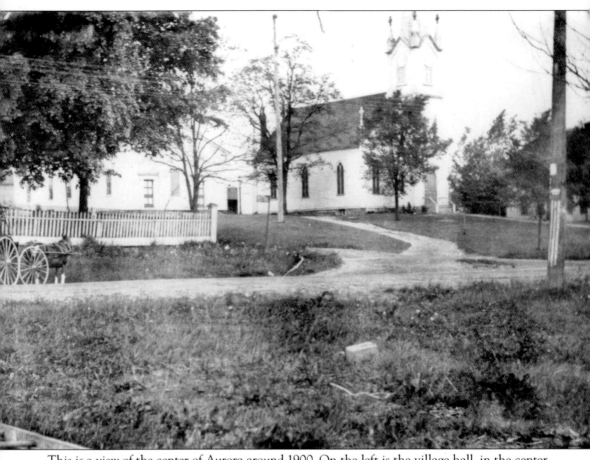

This is a view of the center of Aurora around 1900. On the left is the village hall, in the center is the Church of Aurora, and on the right is the Central School. The fence is at the Nelson Eggleston house.

Four

COMMUNITY ACTIVITIES AND ORGANIZATIONS

Aurora began as a small pioneer community far from "civilization." It may have taken hours to travel to the nearest towns in the early years, which most likely fostered a sense of community and encouraged Aurora citizens to gather together and create exciting events and celebrate happy occasions. As transportation improved and the populations of surrounding cities grew, Aurora continued to thrive and participate in its community events. Plays, vocal programs, study groups, and parades are just a few of the many activities that occupied the leisure time of Aurorans in the past. Today such activities remain a favorite pastime for many in the city.

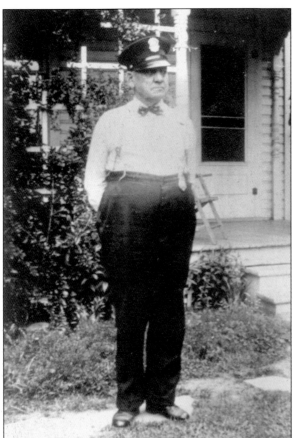

From 1903 to 1943, Samuel M. Miller served as an Aurora police officer. He retired on September 1, 1943, as chief of police. Miller's daughters, Donna Mattmuller and Jane Burns, both are charter members of the Aurora Historical Society.

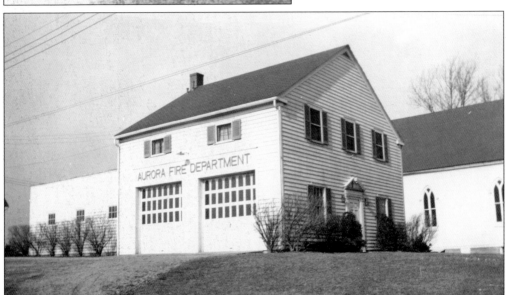

This is the Aurora fire station as it appeared in the 1940s. It was located in the center of Aurora, at the corner of West Pioneer Trail and South Chillicothe Road. This building was eventually dismantled to make way for the expansion of the Church in Aurora.

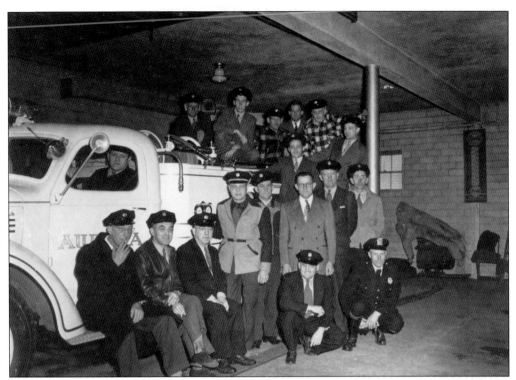

Aurora volunteer firemen pose for the camera in the 1940s.

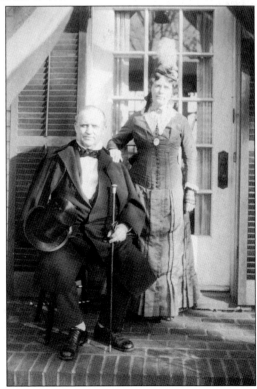

Carl and Elizabeth (Bessie) Hurd Ford stand in front of their home on North Chillicothe Road. They are dressed in costume for the 1930 "Turkey Shoot."

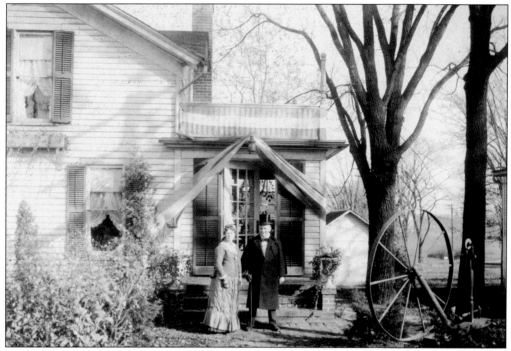

The Fords pose in front of their home. In later years, the house was purchased and became part of the Mario's International Spa complex.

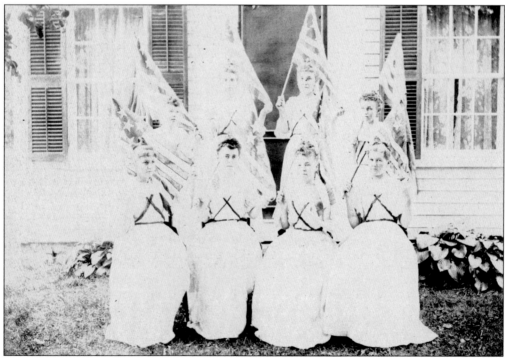

A group of Aurora's beauties celebrate Independence Day in the late 1880s. Parades, picnics, and games filled most holiday events and allowed everyone in attendance to enjoy the day.

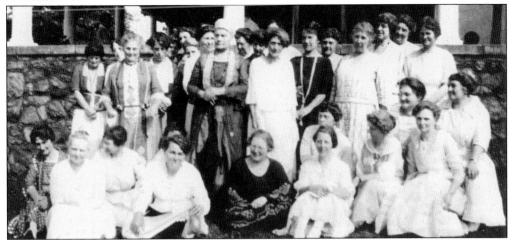

The Ladies Thursday Glee Club in 1920 poses in front of the Harry Harmon House. The glee club met in its various members' homes, practiced songs, and put on local programs for Aurora residents. They raised money for the sidewalk fund and local churches. They are, from left to right, (first row) unidentified, Helen Aldrich, Henrietta Gould, ? Lake, Mae Russell McDonald, Grace Little, Bessie Hurd Ford (slightly behind Little), Florence Henry Eggleston, Clara Phillips, Edith Straight Harmon (behind Phillips), and Saddie Thompson (also behind Phillips); (second row) Carrie Louise Hurd Mowbry, unidentified (behind Mowbry), Alta Baldwin Gould, Florence Lacey, two behind Lacey are unidentified, Elma Little, Carrie Harmon, Jenny Burroughs Eldridge, unidentified, unidentified, unidentified, Louise Harmon, Josephine Brewster, Mrs. Oscar Gilbert, Zoe Lacey Whitney, Mrs. Walter, and unidentified.

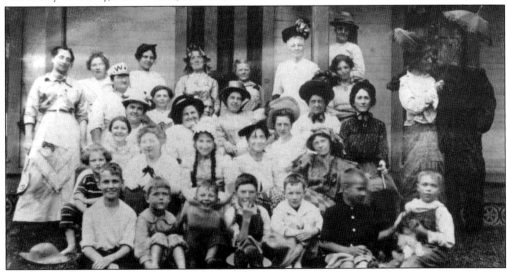

Aurora citizens are dressed for a theatrical presentation early in the second decade of the 20th century. From left to right they are (first row) Seabury Ford, unidentified, unidentified, Alfred Vaughan, Mortimer Larter, Kenneth Lowe, and Bentley Hurd; (second row) Frances Ford, Mae Russell McDonald, unidentified, unidentified, Bessie Hurd Ford; (third row) Donna Larter, unidentified, and Grace Little; (fourth row) Edith Straight Harmon, Mrs. William Phillips, unidentified, Elma Little, Jennie Burroughs Eldridge, and unidentified; (fifth row) unidentified, Maud Russell, unidentified, unidentified, unidentified, Orsie Harmon, Libbie Tousely Bissell, and Luzena Mills with parasol.

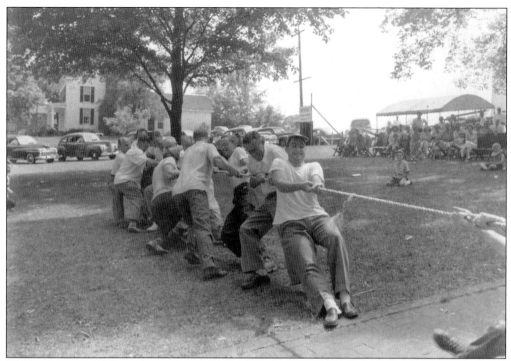

In 1949, Aurora celebrated its sesquicentennial. The community held a parade, picnic, ox roast, and games. Here Aurora men participate in tug of war in front of the fire station, at the center.

During the festivities some young boys competed in a sack race.

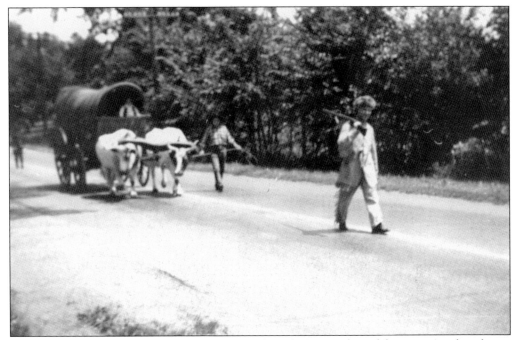

Here is a view of the 1949 parade held during the July 2, 3, and 4 celebration. A yoke of oxen pull a wagon as Bentley Hurd leads them dressed as Ebenezer Sheldon. The parade is progressing southward down Chillicothe Road toward the center of town.

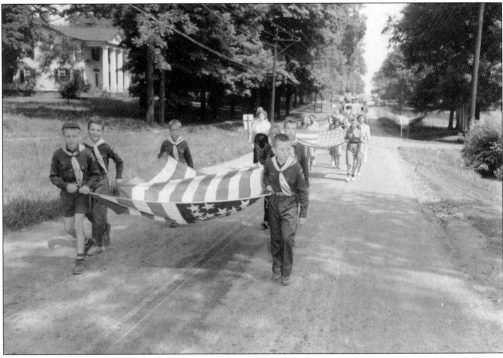

The local troops of Aurora's Boy Scouts and Girl Scouts marched in the parade and helped show their pride in their community.

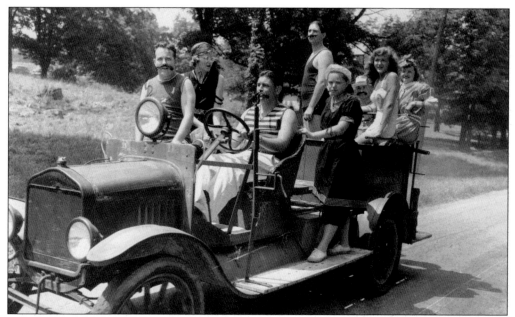

Dressed in the swimming costumes that their parents or grandparents might have worn, several of Aurora's young people are riding in an old car. They are, from left to right, (front seat) Tom Douglas with Charles Petot driving; (second row) Marion Benvoda and Sandy Morrison; (third row) unidentified and Penny Carter; (fourth row) Gertrude Calhoun, and Marlin Hanes.

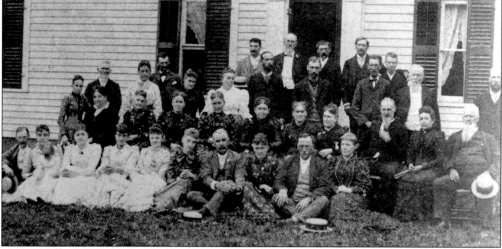

The cast of the *District School*, a 19th century comedy, sits in front of John Gould's home at the top of Gould Hill in 1900. The cast met annually from 1890 through 1910. From left to right they are (first row) William Mills, unidentified, unidentified, Josephine Hurd Brewester, unidentified, Carrie Rizer Parsons, Luna Parker, Willis J. Eldridge, Jenny Eldridge, Rollin Granger, and unidentified; (second row) Hattie Baldwin Heinley, unidentified, Addie Riley, Libbie Bissell, unidentified, Myra Little, Emily Baldwin, Carrie Hurd, Solomon Little, unidentified, and Lester Thompson; (third row) Harvey Baldwin, Helen Gould, Gurdon Riley, Alice Baldwin Gould, Carrie Cannon Harmon, unidentified, unidentified, John Gould, unidentified, and unidentified; (fourth row) unidentified, unidentified, D. B. Lacey, unidentified, and unidentified.

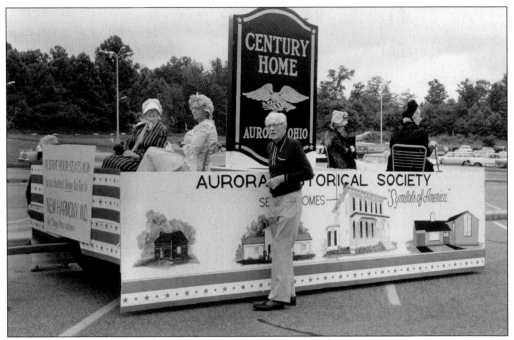

The Fourth of July parade in 1978 included a float by the Aurora Historical Society, formed some 10 years earlier. From the front to the back are Clarabelle Rumbold, Ester Petot, Helen Greenwood, and Laura Geddes. Ted Geddes is walking beside the float.

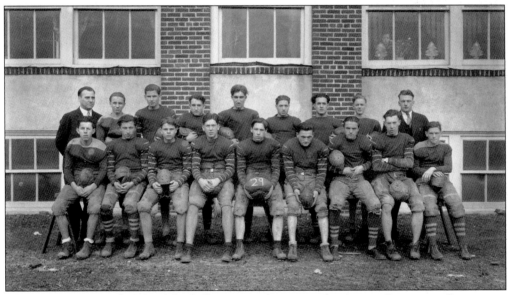

The 1929 Aurora High School football team was known as the Aurora Greenmen. Sports were and are a popular pastime with many schoolchildren and Aurora residents who turn out in large numbers to support their school teams.

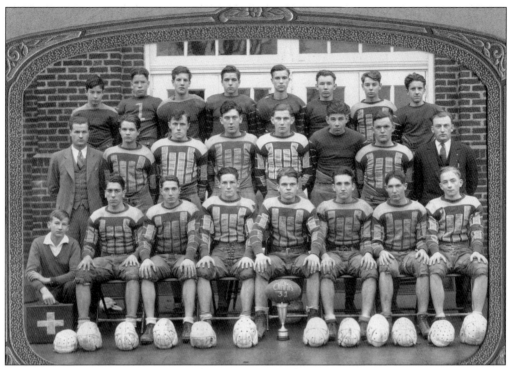

The 1931 Aurora High School football team poses for this photograph.

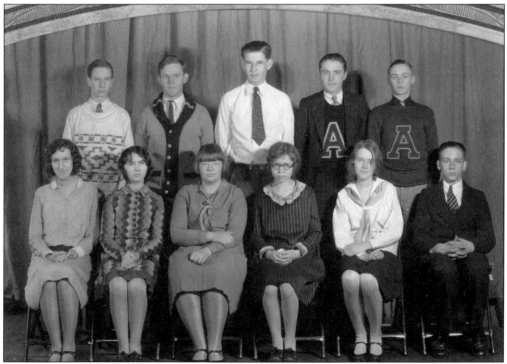

This is the Aurora High School junior class of 1931.

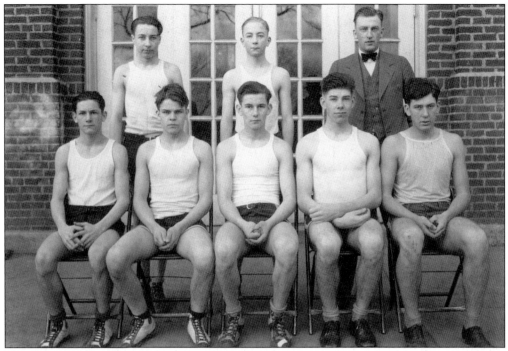

The Aurora track team is seen in this photograph.

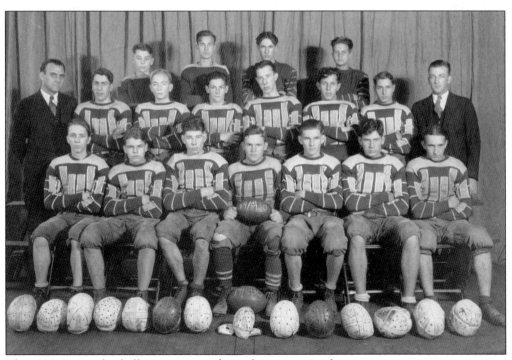

The 1930 Aurora football team poses to have their portrait taken.

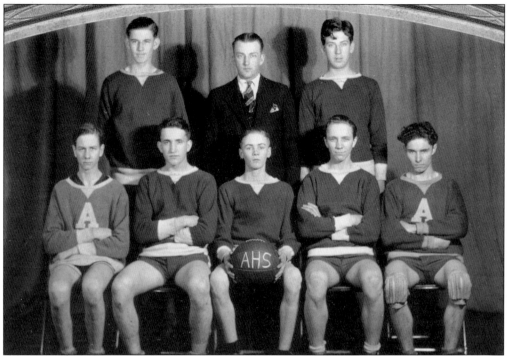

This is the second team of the 1930 Aurora High School basketball team. They ended the season with a 7 to 1 record.

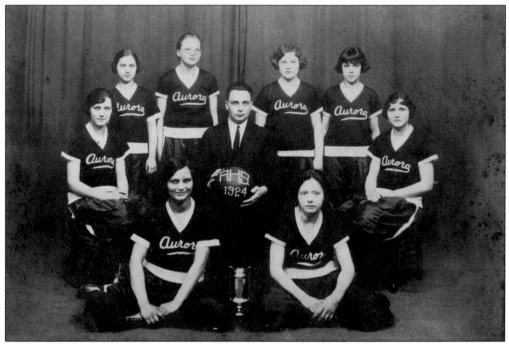

Here is the Aurora High School girls' basketball team from 1924. From left to right they are (first row) unidentified and Grace Miller; (second row) a Dreyer twin, coach Fox, and a Dreyer twin; (third row) Florence Ramsey, Leila Riley, Florence Dreese, and Caroline Lehman.

This Aurora High School basketball team is made up of, from left to right, (first row) three unidentified players; (second row) ? Guyette, Kenneth Chapman, coach Fox, Victor Hurd, and William Hartman.

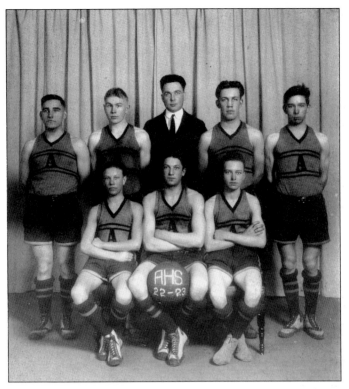

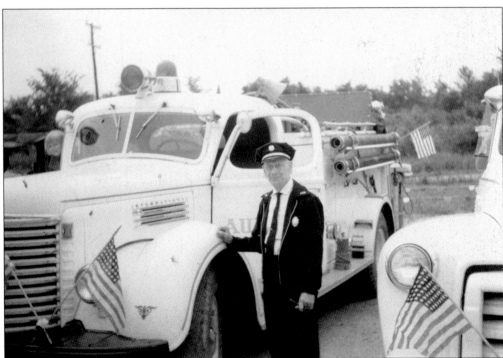

Fireman John McDonald had his photograph taken with the Aurora Village fire truck during this 1949 celebration.

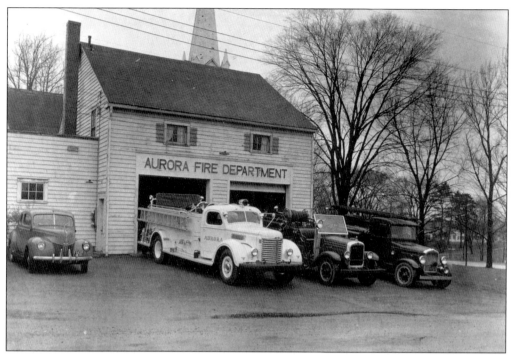

The Aurora Fire Department and trucks are pictured on the corner of West Pioneer Trail and South Chillicothe Road.

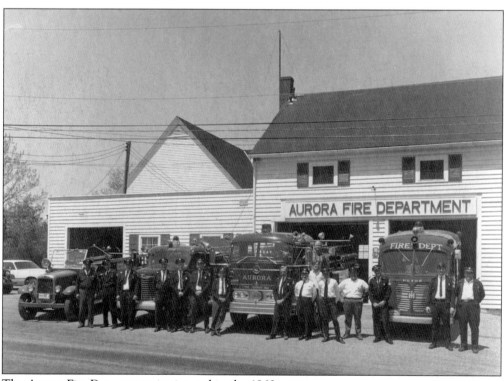

The Aurora Fire Department is pictured in the 1960s.

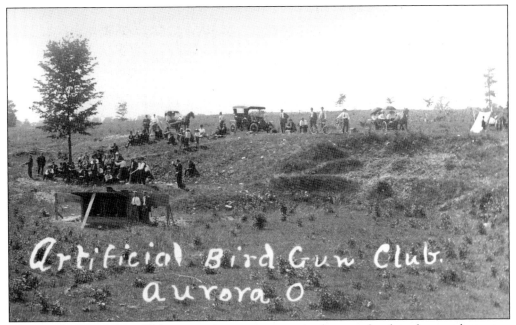

The Artificial Bird Gun Club met in the cow pastures in the area that later became known as the Smythe development, in back of the present Aurora Inn. This club was in existence in the early 1900s.

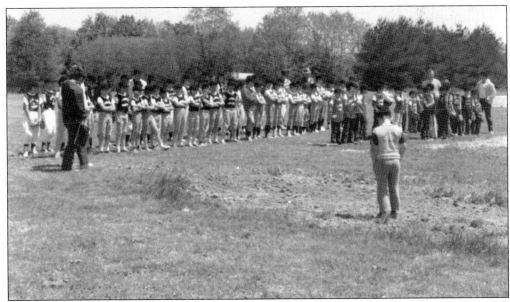

Aurora has always loved its sports, especially baseball. During the spring and summer months, local ball fields are filled as teams practice and play what many consider to be America's national pastime. Here Aurora Little League baseball teams gather before a game in the 1970s.

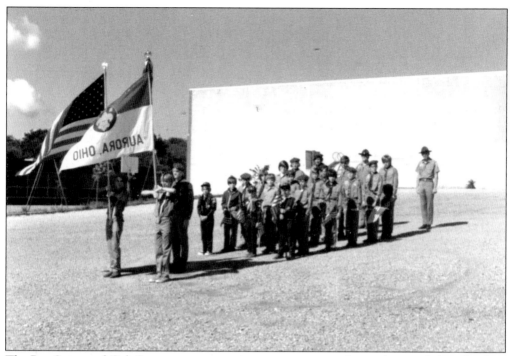

The Boy Scout and Cub Scout programs are important to many Aurora boys and their families. Here they are seen lining up for a parade.

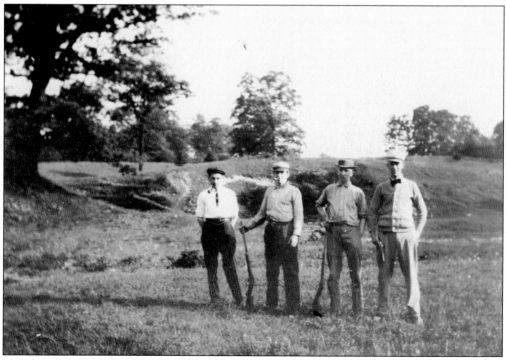

Four friends get together to go hunting in the Aurora countryside about 1920. They are, from left to right, John McDonald, Charles Riley, Art Bemis, and Fred Eggleston.

The land set aside as a World War II memorial was dedicated, during the 1949 sesquicentennial celebration, to the memories of the nine Aurorans who lost their lives. The boulder has a plaque inscribed with the soldiers' names, and the cannon sits near it. The Aurora Memorial Library was later built on the site, and the boulder and cannon now stand in front of the building.

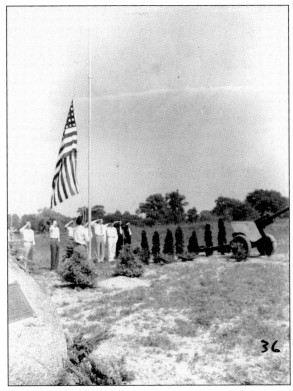

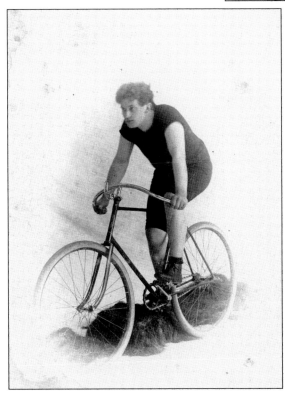

Carl B. Ford poses for his picture to be taken on his bicycle in the late 1880s.

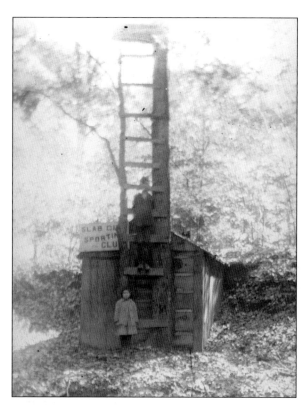

Children play at the Slab City Sporting Club House. Slab City, named for the surplus slabs of lumber from local mills, is near Aurora Station on East Garfield Road.

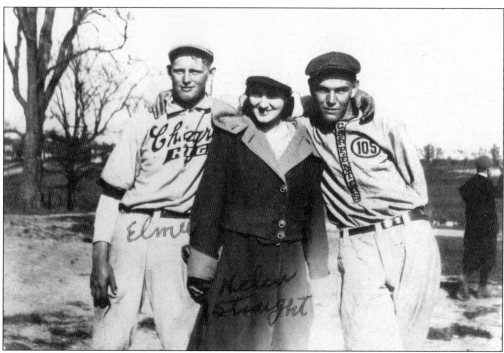

Here are Elmer Cochran, Helen Straight, and Sam Culp in the 1920s. The men wear local baseball uniforms while Straight sports a baseball cap.

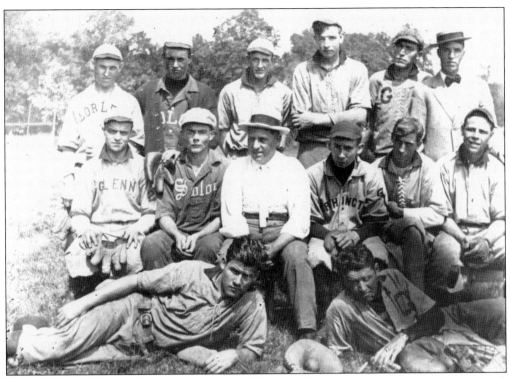

The Geauga Lake baseball team in the early 1920s poses for the camera.

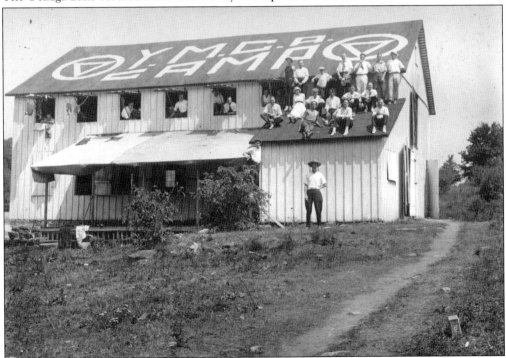

The YMCA camp at Centerville Mills operated for many years. One of its programs brought underprivileged youth from Cleveland to spend time in the serene Aurora countryside.

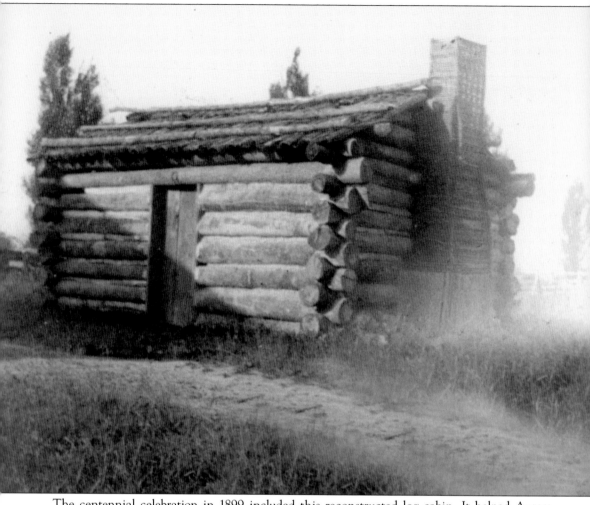

The centennial celebration in 1899 included this reconstructed log cabin. It helped Aurora citizens see what life had been like in the first years of Aurora's settlement. The cabin was erected behind the Church in Aurora, which served as the center gathering place for the festivities.

Five

HARD WORK

Work is a common theme to which everyone can relate, regardless of the era one is discussing. For the people of Aurora, work was often long, grueling, and repetitive. Farmers rose before dawn, tended to their animals, and worked in the fields. Prior to the invention of steam- and gas-powered machines, animal and man power were used to accomplish the myriad tasks that farmwork entailed. Even after newer labor-saving devices became available, many farmers could not afford the expense of new machinery. Aurora's residents worked at innumerable jobs, as dairy men and cheese producers, farmers, cobblers, lumberjacks, millers, store owners, and railroad workers. Although their work might have been diverse, they shared the Aurora scenery and its sense of community and the common value of hard work.

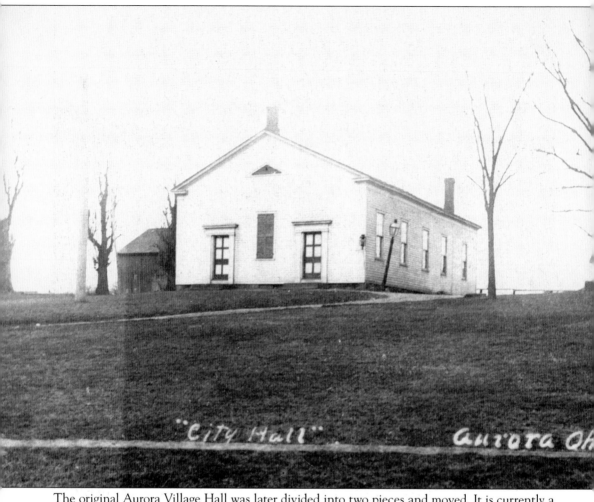

The original Aurora Village Hall was later divided into two pieces and moved. It is currently a part of Aurora City Hall. The barn to the left of the hall is for the Nelson Eggleston property.

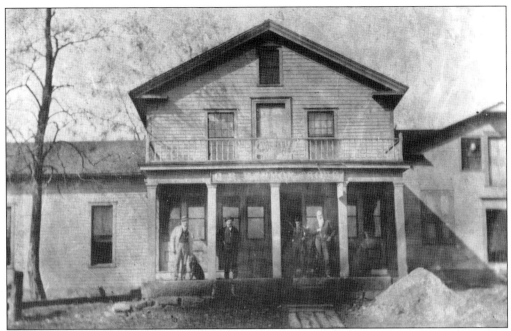

The C. R. Harmon and Sons General Store at Aurora Center was built about 1840. Charles Harmon and employees are pictured in front of the store. The building has been in constant use as a store from its construction to the present day.

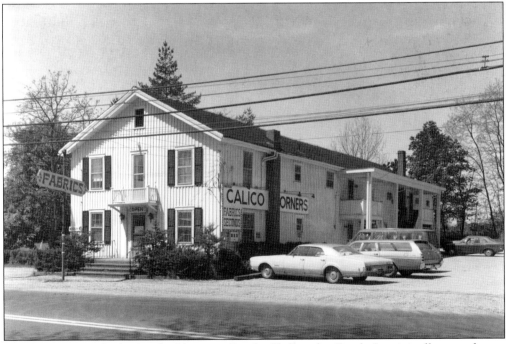

Charles Harmon built this building on South Chillicothe Road. It originally served as a cheese warehouse. Through the years, it has seen various commercial uses as well as acting as rental apartments.

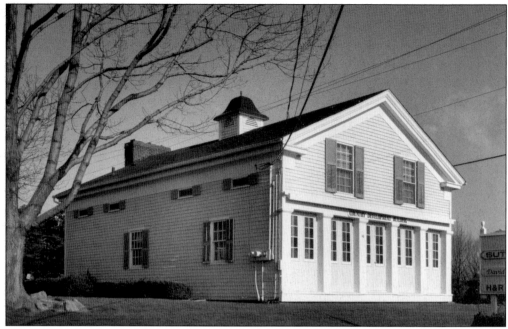

The James Converse Store located on the southwest corner of Garfield and Chillicothe Roads was, for many years, the store of merchant Hopson Hurd. As a young man, Hurd came to Aurora in 1813 and was the chief business force in Aurora's first century. At the time of his death in 1869, he was the largest landowner in Aurora and one of Portage County's wealthiest residents.

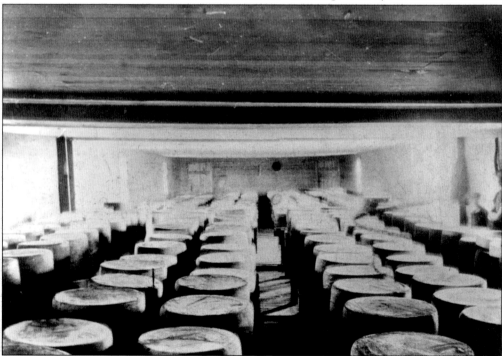

Here are wheels of cheese aging in the Hurd cheese warehouse. Cheese was shipped via the railroad to hundreds of cities across the country and locations in Europe.

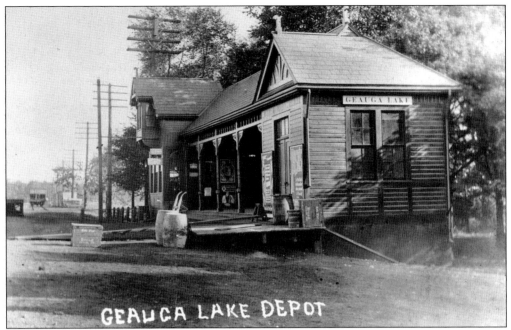

GEAUGA LAKE DEPOT

With the advent of the railroads, the line to Aurora first came through the Geauga Lake Depot, built in 1887. It burned around 1905 and was later rebuilt. John McDonald's father, W. H. McDonald, was stationmaster here. The freight house is to the right, and the ticket office is to the left. In the summers, 500–600 people came to this station daily to visit Geauga Lake.

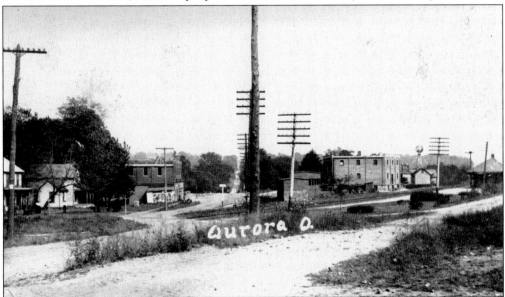

Aurora O.

Aurora Station developed into an important part of Aurora because it brought people, via the railroad, as well as goods and supplies to and from this area. This is Garfield Road, looking east with Gould Hill in the background around 1915. The railroad station is to the far right. To the left is Charles Russell's icehouse and windmill. The brick building to the left is the grocery and dry goods store and post office, built in 1899 by Frank M. Treat. The house to the far left was stationmaster W. H. McDonald's house.

The Frank M. Treat Store at Garfield Road, near Aurora Station, was built around 1900.

This is the east side of the Aurora House Hotel and the livery stable. The livery stable in back later became Art Mowl's first garage. Gertrude McDonald stands in the garden.

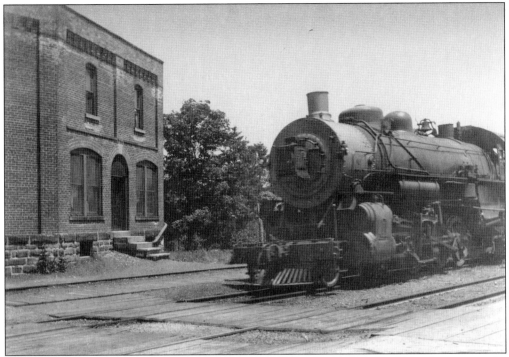

As a steam locomotive pulls into Aurora Station, it passes the back of Treat's store in the early 1900s.

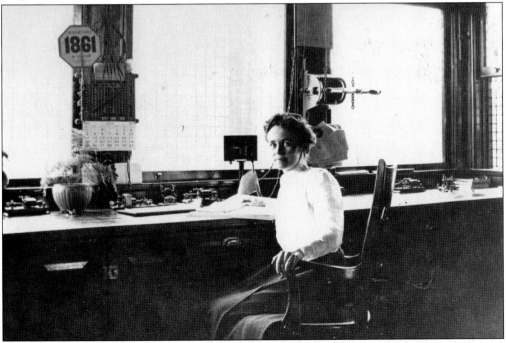

This is what the Aurora Station telegraph office looked like in 1905. Bessie Hickox was the telegraph operator at the time when 80 to 90 trains a day came through Aurora. The trains were controlled by the telegraph.

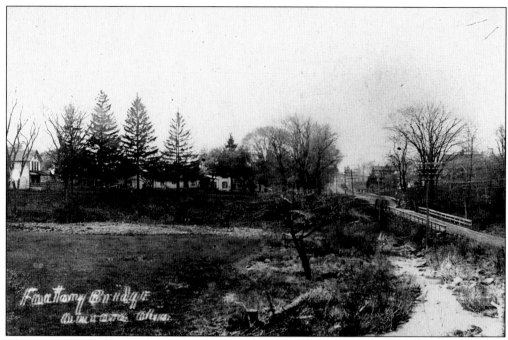

This picture looks west at the Factory Bridge across the Chagrin River, east of Aurora Station, at the foot of Gould Hill on East Garfield Road.

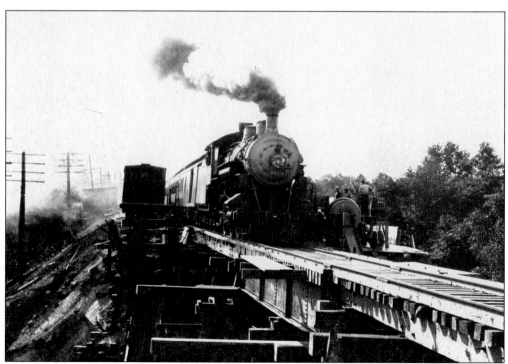

In the spring of 1913, a disastrous flood destroyed the trestle across the Chagrin River at Aurora Station. Here the bridge is seen during reconstruction.

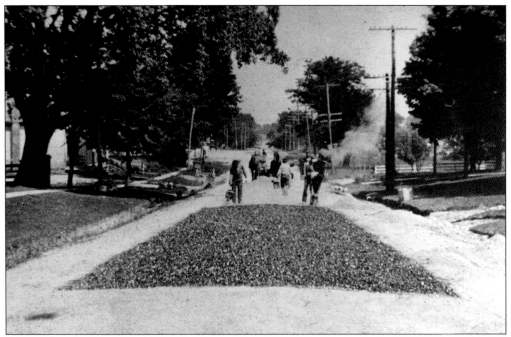

The first Aurora road to be paved went from the Hurd Hardware Store on East Garfield Road west to present-day State Route 306, then south past Harmon's store at Aurora Center. This picture was probably taken near 270 South Chillicothe Road about 1921.

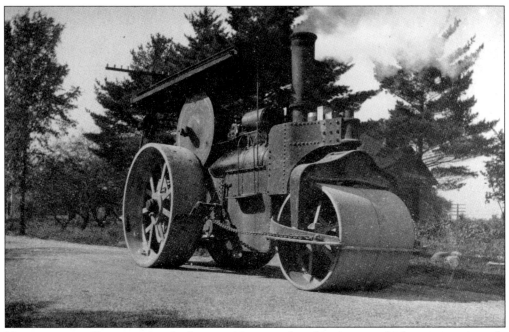

Here is a steamroller impacting the first macadam paved road in Aurora, which ran approximately one and a quarter miles from Aurora Station to the center. Such activities would be welcomed by residents whose travel would be improved by the paving as well as the decreased amount of dust and mud on the roads.

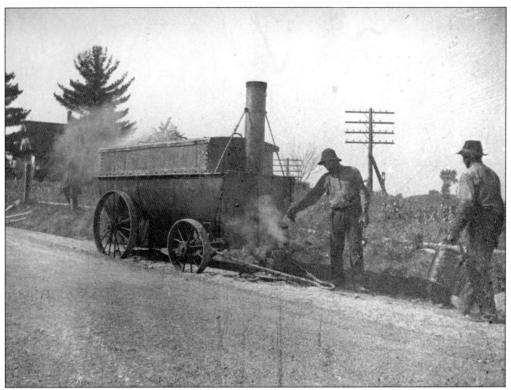

Here men are working on the first paved road in Aurora, on East Garfield Road, near the railroad tracks.

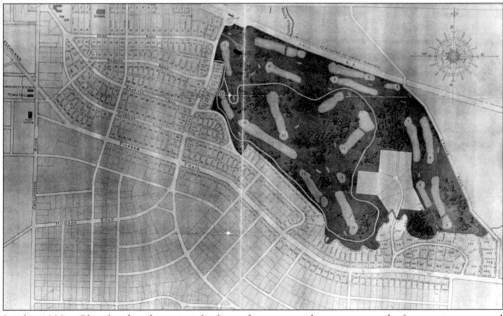

In the 1920s, Clevelanders began to look to the surrounding countryside for a quiet pastoral community. Aurora met that need, and Cleveland developer Alfred Burns Smythe commenced the planning of "Aurora—Cleveland's First Commuters Village."

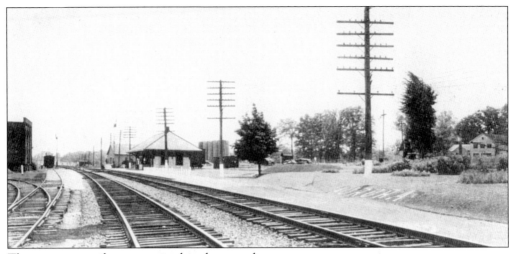

The commuter rails are seen in this photograph.

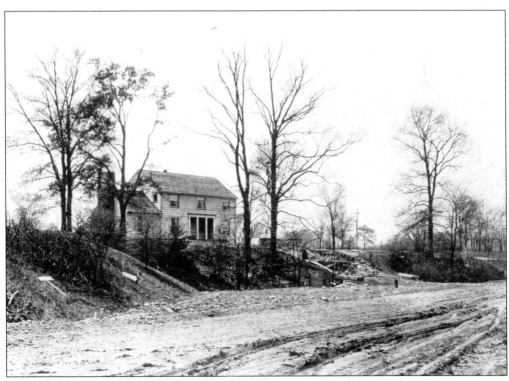

Development began soon after Burns planned his "commuters village" in the 1920s.

Spacious homes with wooded lots began to pepper the area.

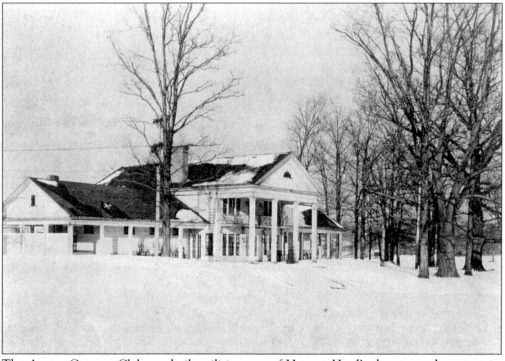

The Aurora Country Club was built utilizing one of Hopson Hurd's cheese warehouses as its main block. The design is described as the Western Reserve style and was built in 1927.

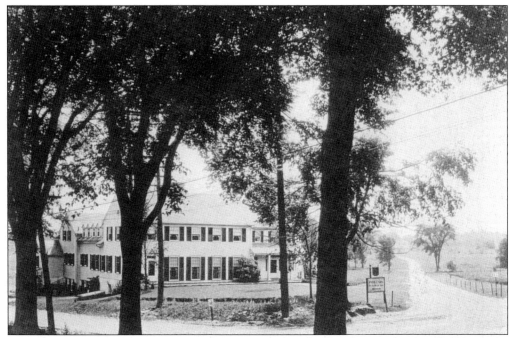

A major enticement to visit Aurora and the country was the Smythe's Aurora Inn, built near the corner of State Route 82 and Chillicothe Road. The inn featured gracious country-style dining at its very best.

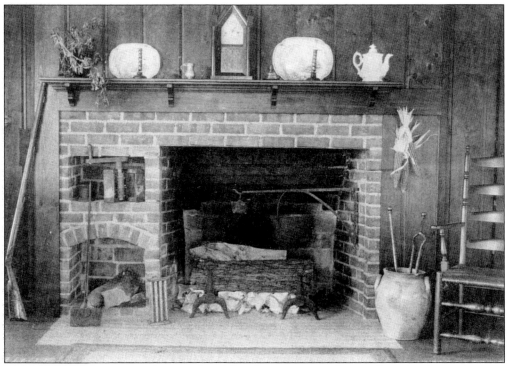

The interior of the inn was decorated with local antiques to enhance the visitor's experience.

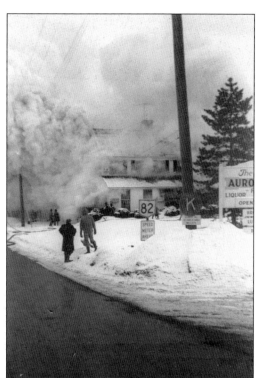

In the winter of 1950, fire raged through the Aurora Inn, destroying a significant portion of the structure.

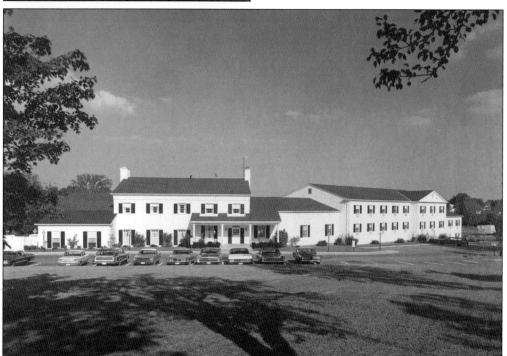

This photograph shows the Aurora Inn soon after it was rebuilt. The interior designer was Robert L. Hunker, and the architect was Jack Alan Bialosky of Cleveland. It is one of northeastern Ohio's foremost hostelries.

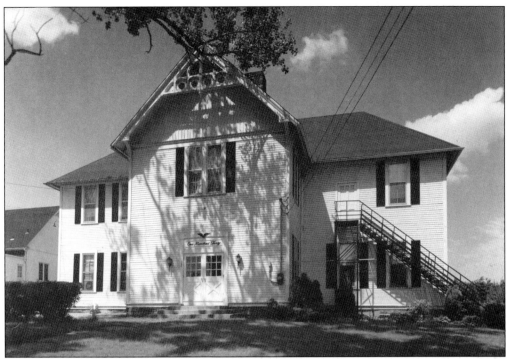

This is Aurora City Hall as it appeared in 1968. Renovations made this previous schoolhouse a useful and beautiful city building.

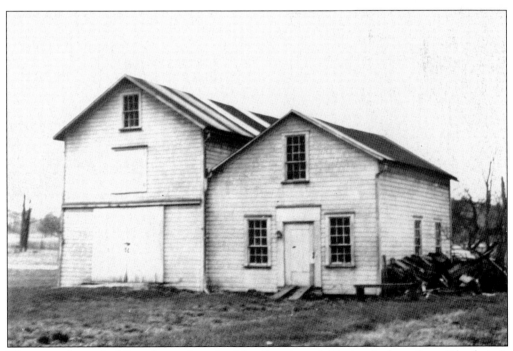

These are the outbuildings located on the John Erastus and Clarissa Jackson farm. The farm is located at 1070 North Chillicothe Road, and the home on this property was built in 1840.

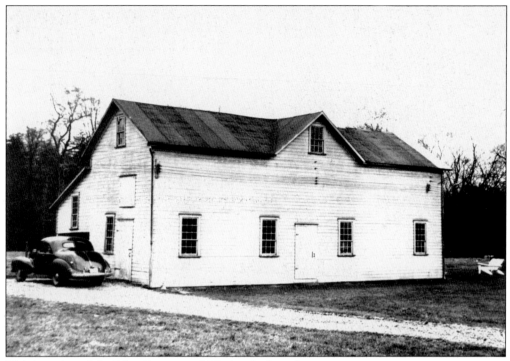

This is a view of the John Erastus and Clarissa Jackson barn.

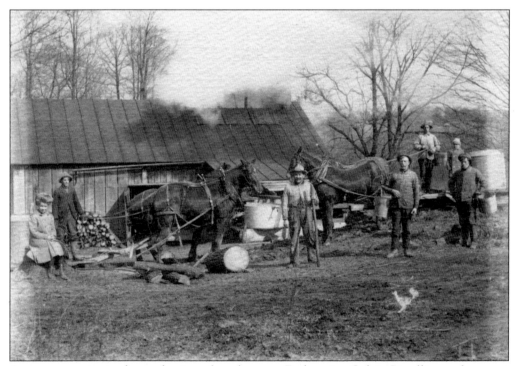

Aurora was active in the production of maple syrup. Each spring Calvin Bissell's sugarhouse on Bissell Road bustled with activity.

Farmers in Aurora, Hudson, and Mantua produced syrup from maple trees tapped in the early spring. Here is the old sugarhouse located at 1157 Page Road, on the Israel Harmon farm.

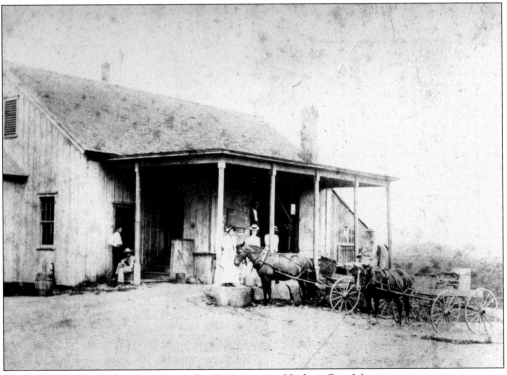

The Eldridge cheese factory operated at 990 Aurora–Hudson Road for over a century.

The Eldridge building survived the demise of the cheese industry and was later converted into a home in the 1970s.

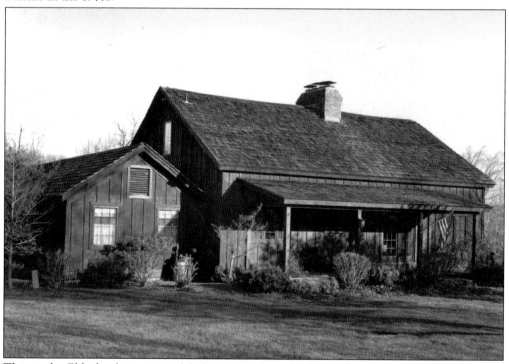

This is the Eldridge house remodeled as a comfortable Aurora home. From its exterior, one would never guess that it once was the source of cheese production.

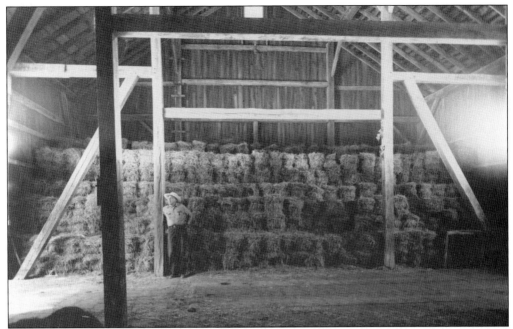

Since so many of Aurora's families farmed for their living, hay was necessary for feeding the animals. Here is the interior of the barn at 1113 East Pioneer Trail filled with hay to get the farmer and his cattle through the winter. This barn is near the original Ebenezer Sheldon cabin site.

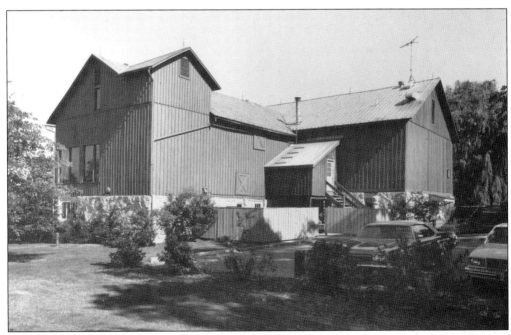

This is the Walden Barn on Bissell Road. Walden is a planned community consisting of condominiums, houses, a clubhouse, golf courses, a country club, and a restaurant. This community was developed by Manny Barenholtz. The barn serves as one of its two dining establishments, which boast gourmet meals. The barn was originally part of the Solomon Little farm.

This picturesque carriage barn at 411 East Garfield Road served the Chester R. Howard house. The house, built in 1853, is known by many in Aurora as the cobblestone house and is renowned in Ohio for its architecture.

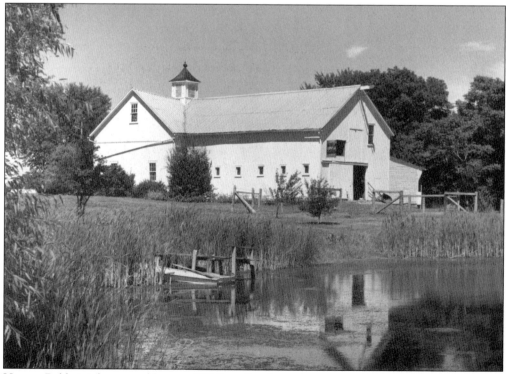

Harvey Baldwin's house and barn at 899 Page Road were constructed about 1840.

Located at 1001 North Chillicothe Road, this barn served the John Jackson farms.

This is a fine example of a double-silo barn, which was once quite popular in this area. It belonged to Carlton J. Payne and is located at 1050 East Mennonite Road.

The barn and grain silo at 55 North Bissell Road were a part of the Frank Hurd properties. Hurd inherited large land holdings in Aurora on which he built housing for his farmworkers.

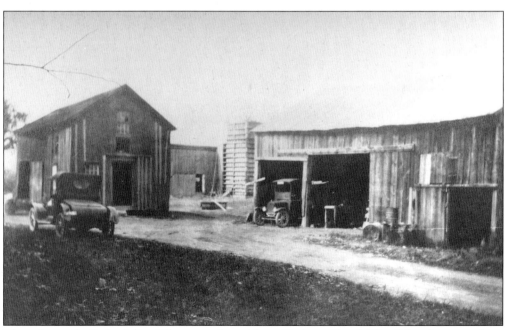

These barns, built for Julius Riley, were located on Cochran Road. The Riley farm was later occupied by the Lewis Cochran family.

These are the barns at the Otis Parsons Case farm, located at 747 North Chillicothe Road. Case's grandfather Capt. John Seward, a Revolutionary War soldier, built his house and barns in 1825.

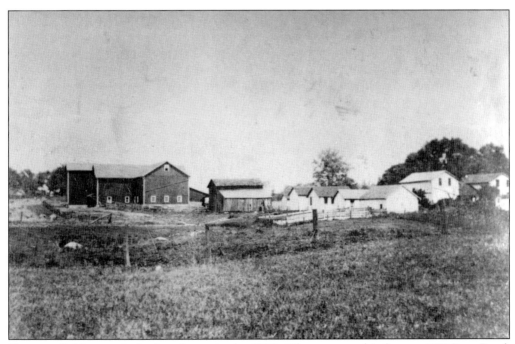

Ebenezer S. Harmon built these barns in the 1830s. They were on his farm at 1192 Page Road. They were later acquired by the Howard Spaeth family.

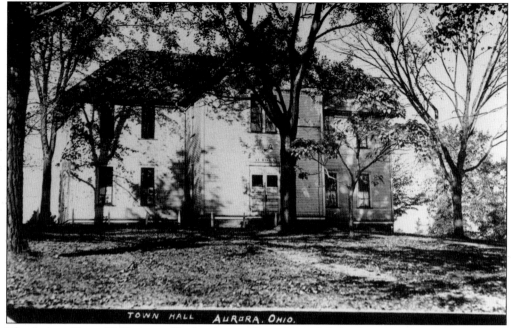

The Aurora Town Hall, originally the Aurora Consolidated School, is seen here as it appeared in 1955.

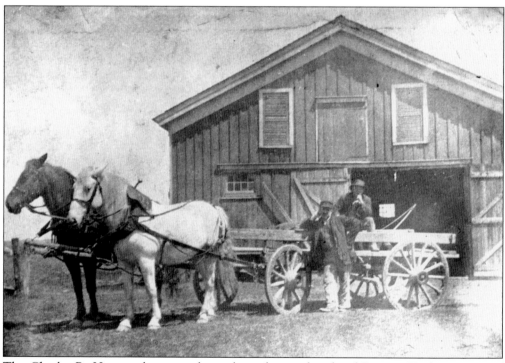

The Charles R. Harmon barn was located on the north side of Pioneer Trail, just east of Chillicothe Road. A team of horses and wagon prepare to work in the field.

Six

CENTURY HOMES

Many of Aurora's houses have been moved at least once from their original sites. In the last half of the 1800s and early in the next century, owners recycled their buildings for other uses. Prior to modern equipment, moving a home was a difficult task. It was done in the winter, when the frozen ground best supported the jacks and logs used as rollers. Oxen teams pulled the buildings as large logs, placed under the load, acted as rollers. As the house moved over the rolling logs, men pulled them out and again placed them under the front of the load, creating a primitive conveyor belt.

Aurora contains a large number of historic "Century Homes." To be registered as a century home, the owner must submit information regarding the home to the Aurora Historical Society.

A large area of Aurora is designated as a historic district. The historical society conducts historic home tours and has published a walking tour of its historic homes. These homes help tell the city's story and reflect the Western Reserve architectural styles and New England's influence of its early settlers.

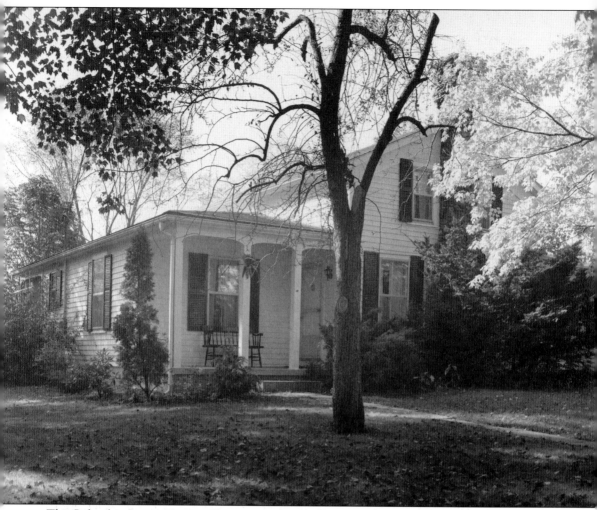

The Columbus Jewett Harness Shop was originally located in the center of Aurora when it was built in 1830. In 1868, the shop was moved to its current location at 73 Maple Lane. It was set on the basement foundation of the Baptist church.

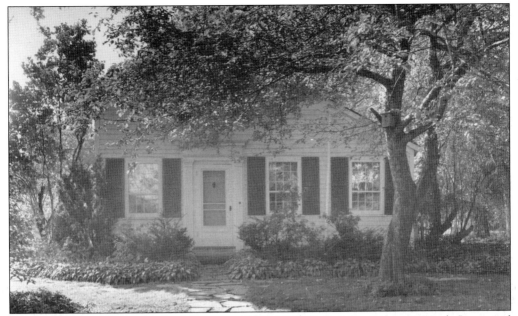

The James Jewett house was built between 1846 and 1850. It is located at 29 Maple Lane, and its first owner was an American Civil War veteran who is buried in the Aurora Cemetery. A newspaper story dated July 19, 1972, relates the story that during the War of 1812, a detail of Aurora's militia mustered in what is now the front yard of the James Jewett house and marched toward Cleveland to defend the country.

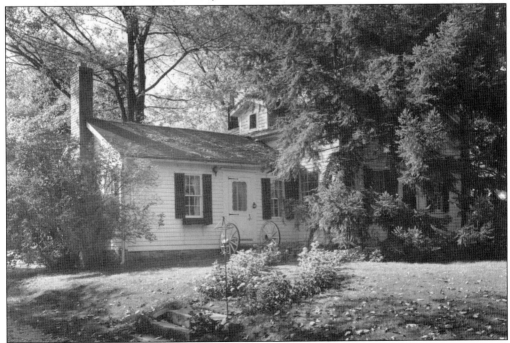

This is the Charles Dudley house at 47 Maple Lane. It was constructed between 1830 and 1835. In 1926, the house was moved from the corner of Chillicothe and Garfield Roads to its present location.

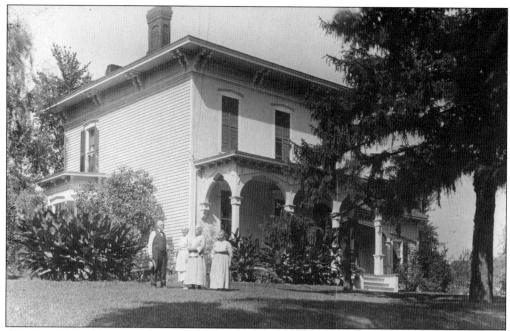

Rev. John Seward was the original owner of this property. A portion of his home is part of later remodeling done by Charles Harmon. The house is of Italianate architectural style and is located at 84 South Chillicothe Road. Harmon and his wife, Hannah, stand outside the home and chat with neighbors in the early 1900s.

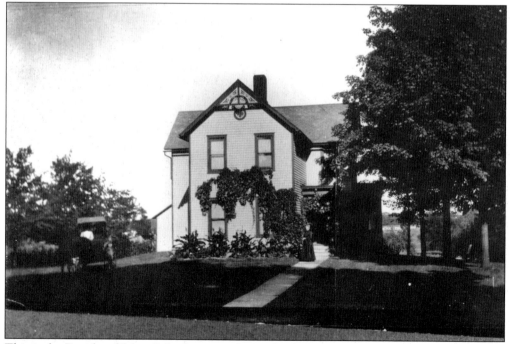

This is the David and Mary Riley house at 59 South Chillicothe Road. David, a descendant of early Aurora pioneer John Riley, retained the family farm and, at his retirement, moved to this fine in-town dwelling.

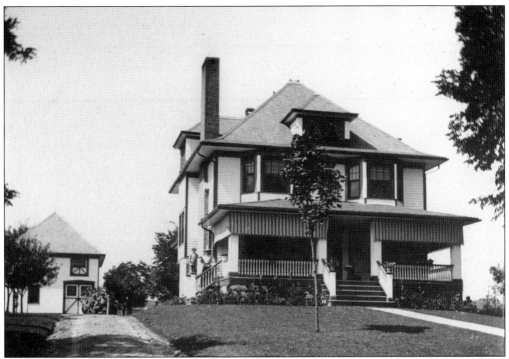

Lee H. Gould, mayor of Aurora Village, resided at this home at 18 South Chillicothe Road. Gould served as mayor in the early 1920s.

This Federal-style home is the William R. Henry house, located at 103 South Chillicothe Road. Henry was a local merchant in business with Charles Harmon. The home, built in 1837, was recognized and chosen to be included in the Historic American Building Survey conducted in the early 1930s.

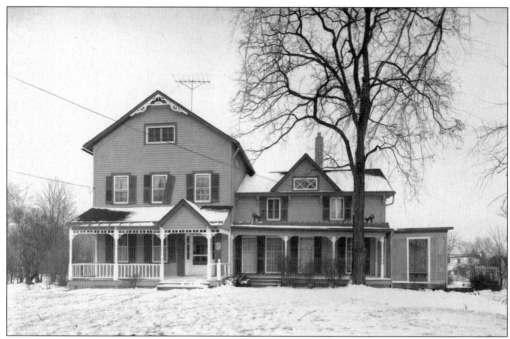

This home was affectionately known as the "Cat House" for the two silhouetted cats on its roof that appeared in the 1960s. The home was the residence of Charles Rollin Harmon and is located at 141 East Pioneer Trail. It was built in 1839.

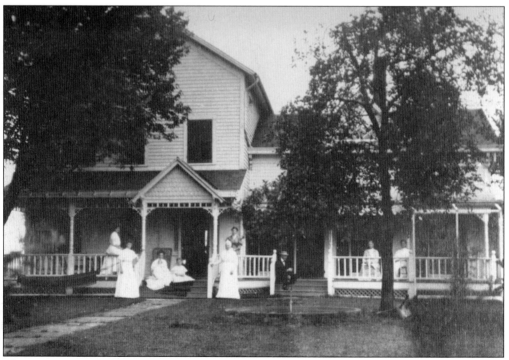

This is a view of the Charles Rollin Harmon home in 1905 with Orsa Bentley Harmon and friends.

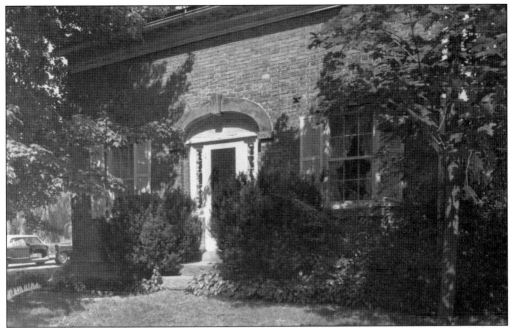

This is the Chauncey Eggleston house at 432 Eggleston Road. This brick Federal-style home belonged to a significant entrepreneur in both Aurora and Chagrin Falls. Eggleston was the son of Benjamin Eggleston, who arrived in Aurora in 1807 and built a wooden house to the north of the present building. Chauncey inherited the property and built this attractive house in 1831.

The Federal-style Roswell Bissell house is located at 981 Winchell Road. Bissell was the son of Robert and Thankful Cheeseman Bissell, who came to Aurora in 1806 from Middlefield, Massachusetts.

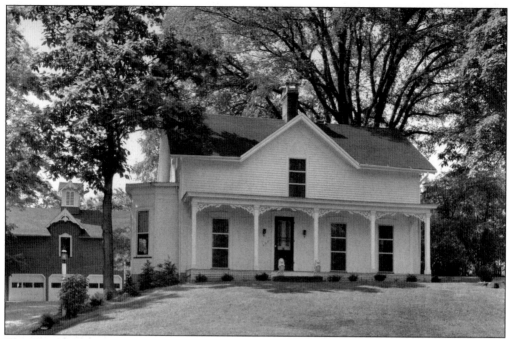

The Charles Russell house was built in 1868 at 356 East Garfield Road. Russell came to Aurora Station at the end of the Civil War and became its postmaster and operated a general store. He was a major influence in the Aurora Station area.

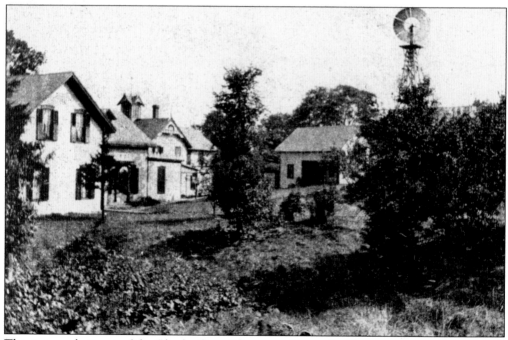

This is an early image of the Charles Russell house and its outbuildings.

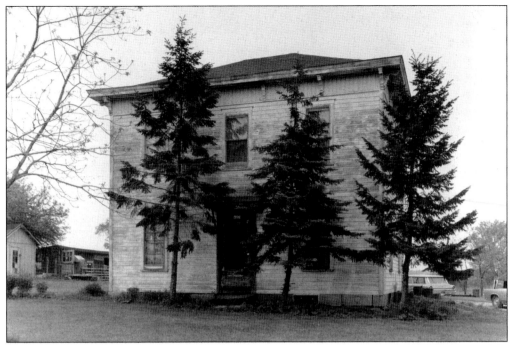

The Charles R. Harmon house at 682 Page Road was built about 1880. It is of Italianate style and was built near the site of the original Harmon family homestead in the southeast quadrant of Aurora.

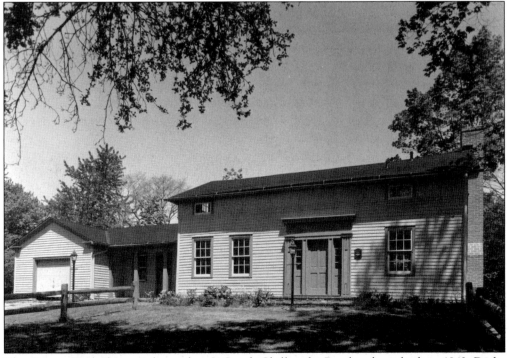

The George Drake house is located at 64 South Chillicothe Road and was built in 1842. Drake was a shoemaker. The home is in the early Greek Revival style so often seen in Aurora.

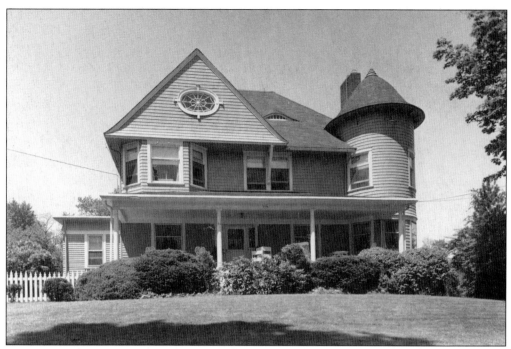

The 1898 Queen Anne–style home of Willis J. and Jennie Burroughs Eldridge is located at 50 South Chillicothe Road. Willis was a prominent cheese producer who owned 16 cheese factories by 1900. One was located in Aurora while the rest dotted surrounding areas.

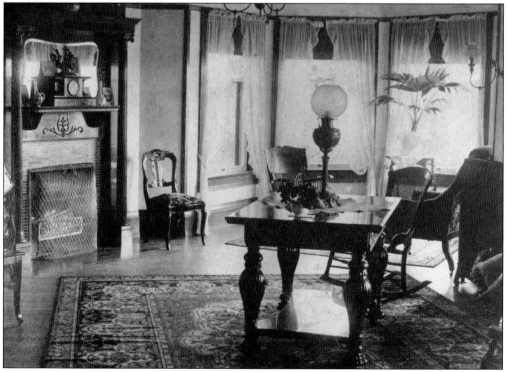

This is an interior view of the fashionable Willis J. Eldridge home's parlor.

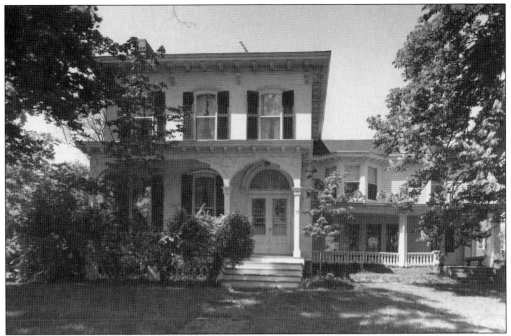

This 1870s Italianate home is the Frank Hurd house located at 28 South Chillicothe Road. It was the home of Aurora's prominent dairy industrialist and cheese producer. The house is actually an 1874 remodeling of a modest dwelling originally build in the 1840s.

This is the Henry D. Burroughs house. It is located at 51 South Chillicothe Road and was built in 1869. It is a fine example of a mid- to late-19th-century country home.

Early settler Oliver Spencer built this house at 909 East Mennonite Road between 1838 and 1840. It is located on the high ground, east of what is now known as Sunny Lake.

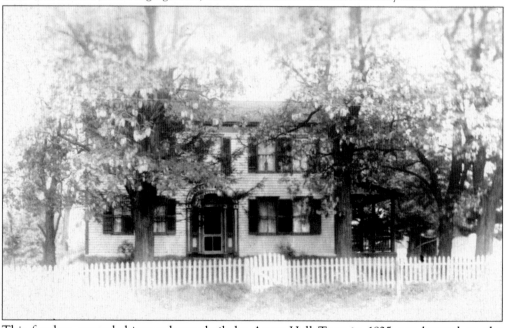

This five-bay, central-chimney house built by Amos Hall Treat in 1825 was located on the Cleveland Road. Treat, a prosperous farmer, also ran a general store in Bainbridge. A fire destroyed the home in the 1950s. The home is on the Historic American Building Survey of the 1930s. The front door entablature, with its arched fan and decorations, is preserved and on display in the Aurora Historical Society's museum.

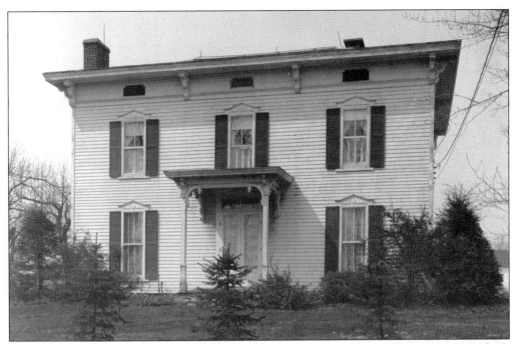

This Italianate home is the Frank Hurd house. It is located at 55 Bissell Road and was built about 1870.

Mark Woodruff first opened his hotel in 1835. The hotel boasted a tavern, meeting rooms, and a dance hall. Moses and Eliza Gray owned and operated the hostelry from 1853 to 1881. People came from miles around, and even out of their way, to sample the famed cooking of Eliza. The hotel was originally constructed on South Chillicothe Road, just south of Garfield Road. Around 1900, it was moved to its present location at 35 East Garfield Road.

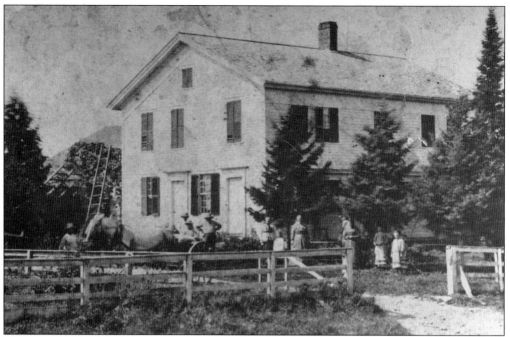

The Capt. John Seward house was built in 1825. It is located at 747 North Chillicothe Road. Built by Revolutionary War soldier John Seward and inherited by his grandson Otis Parsons Case, it was lived in by Seward descendants until well into the 20th century.

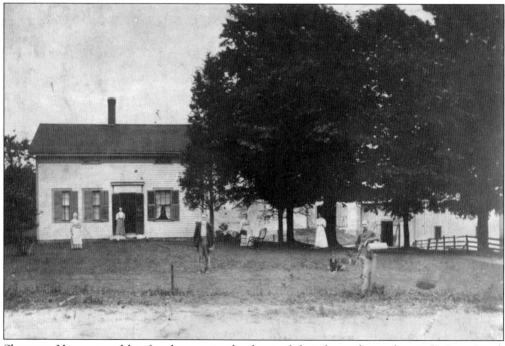

Sherman Harmon and his family pose in the front of their home located at 1157 Page Road. Sherman, the grandson of Col. Ebenezer and Mary Sheldon Harmon, was born in Aurora, near Sunny Lake. His home was constructed in 1848.

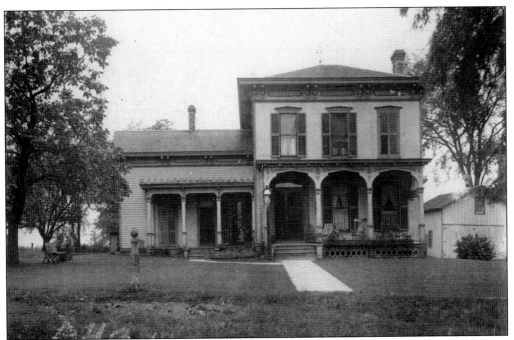

The Henry Clayton Harmon house is located at 40 East Pioneer Trail. The Italianate home was built in 1872 for the son of Aurora merchant Charles Harmon. A fire destroyed a portion of the rear of the house in the late 1800s, resulting in the death of a female renter.

This modest structure was the home of Bessie Hickox and her sister Ella. From here the sisters maintained the first telephone exchange in Aurora. The home is located at 543 East Garfield Road, in the Aurora Station district.

ACROSS AMERICA, PEOPLE ARE DISCOVERING SOMETHING WONDERFUL. THEIR HERITAGE.

Arcadia Publishing is the leading local history publisher in the United States. With more than 3,000 titles in print and hundreds of new titles released every year, Arcadia has extensive specialized experience chronicling the history of communities and celebrating America's hidden stories, bringing to life the people, places, and events from the past. To discover the history of other communities across the nation, please visit:

www.arcadiapublishing.com

Customized search tools allow you to find regional history books about the town where you grew up, the cities where your friends and family live, the town where your parents met, or even that retirement spot you've been dreaming about.

MAP SEARCH